PALM SPRINGS

California's Desert Gem

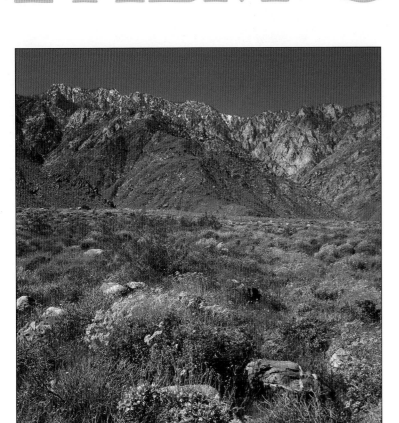

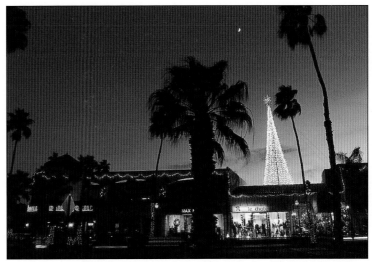

Photography and text
by Ren Navez

WESTCLIFFE PUBLISHERS

westcliffepublishers.com

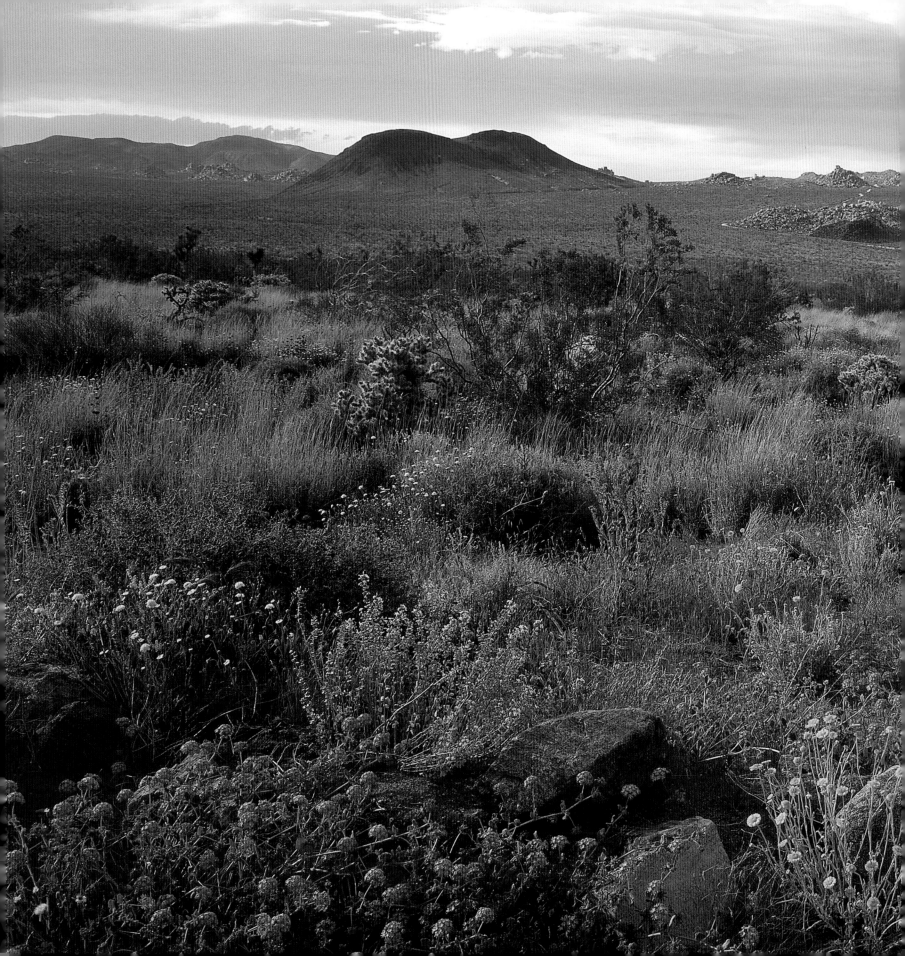

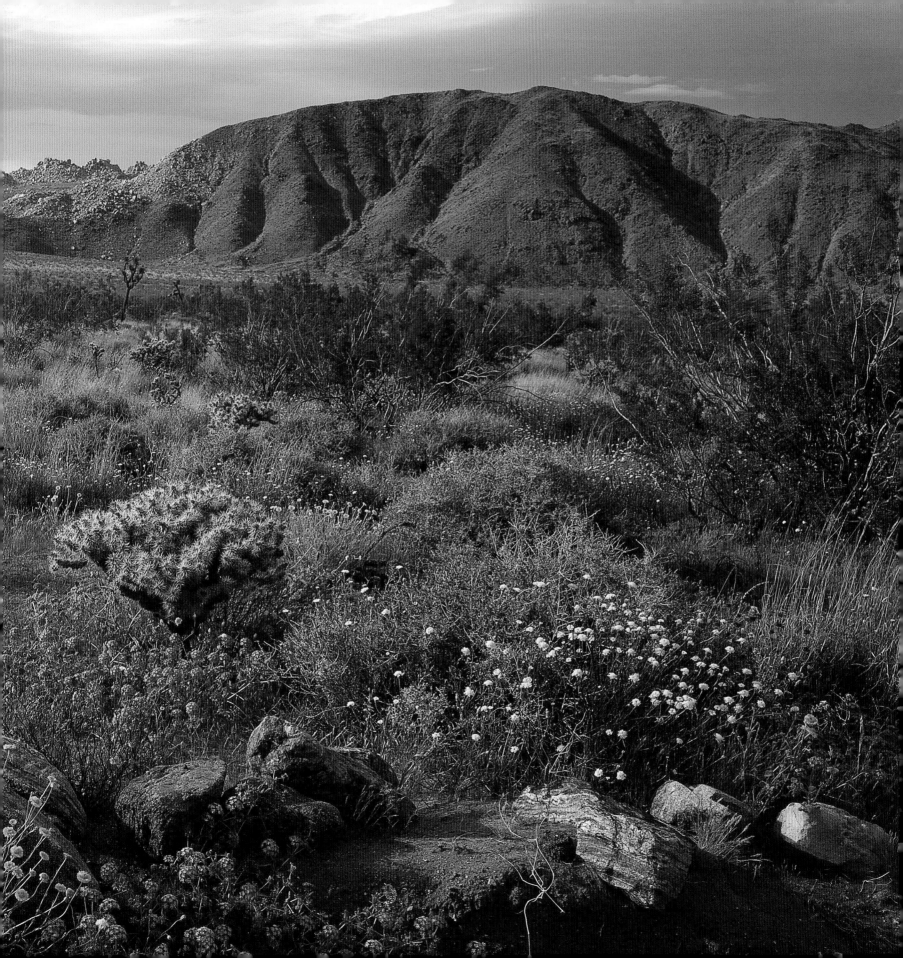

ACKNOWLEDGMENTS

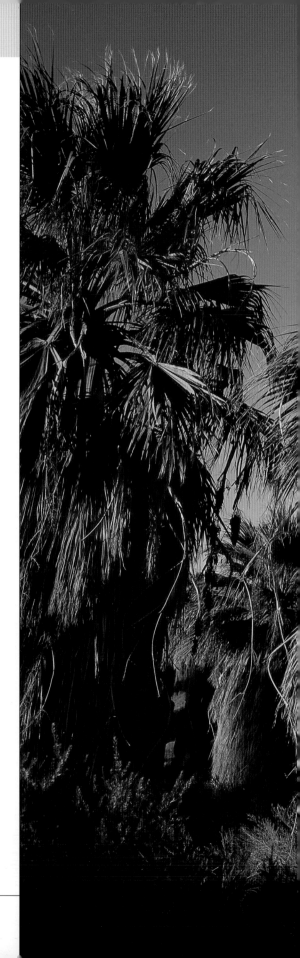

I want to thank Jenane Patterson for her faith and support, Michael Stern, whose early help was motivational, and Linda Doyle of Westcliffe Publishers for her guidance throughout the publishing process. This book represents experiences beyond my own, so I must thank the Clan of the Cave for their companionship and inspiration on many desert nights: Johnny TooBad, Tony (the shaman), Shawn, Michel, Bobbi and Gregory, Renaud (avec), Johnny and Dottie, Mathilde and Mike (both of 'em), Lynda and David, Brian and Ronette, Billie and Jeff, Vladi, Caroline and Francis, Kathy, Jeffrey and Marie, Tiger, C, Margaret and Peter, Alex, Esq. (for many travels)—and all those who have come out with us to howl at the moon and revel in the greater mysteries, especially the next generation we've broken in.

This book is dedicated to Shawn,
who opened me to the desert,
and to our son, Joshua,
who opened my heart to life.

Title page: Chino Canyon (left) and El Paseo Drive at Christmas
Preceding page: Pleasant Valley, Joshua Tree National Park
Right: Coachella Valley Preserve

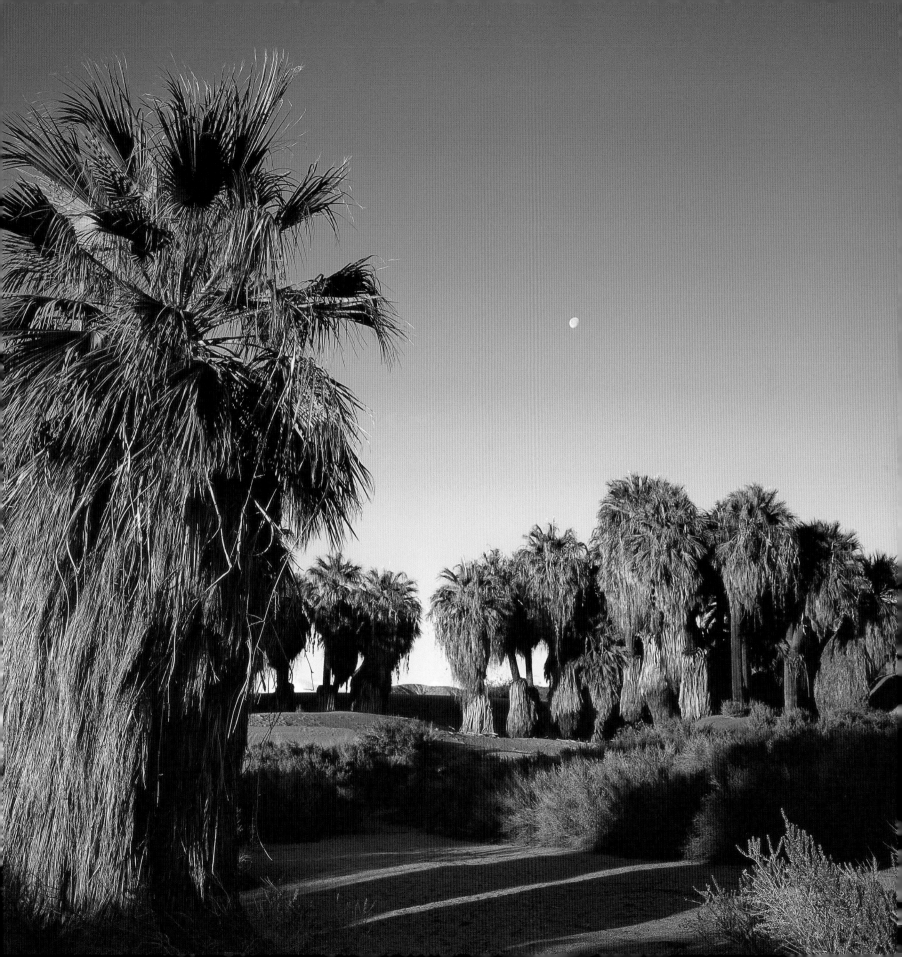

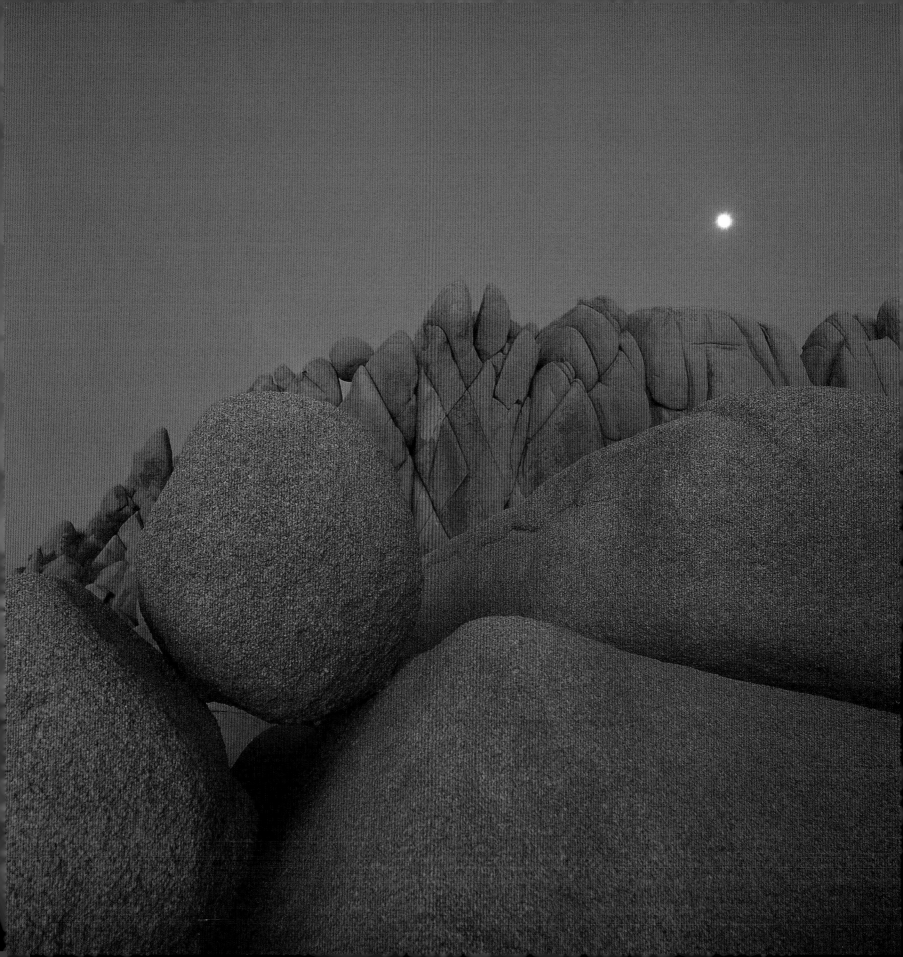

CONTENTS

Left: Jumbo Rocks, Joshua Tree National Park
Below: Carrizo Creek area
Right: Motorbike riders at Algodones Dunes

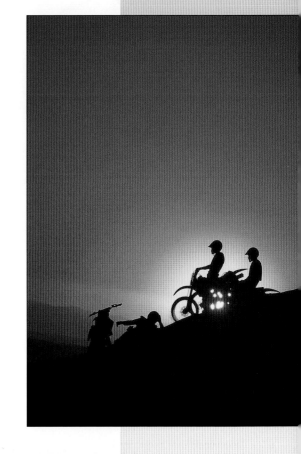

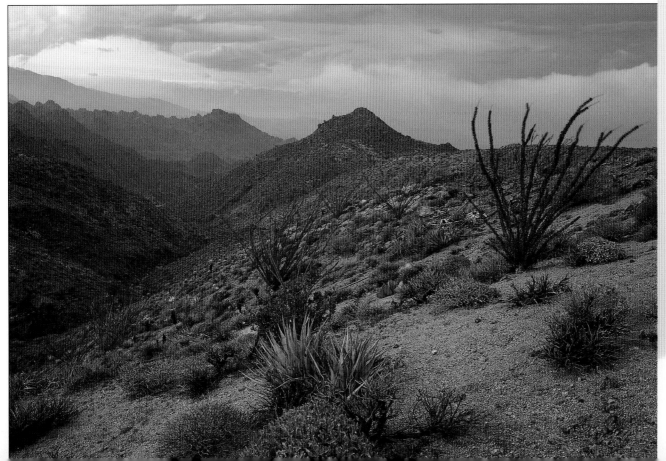

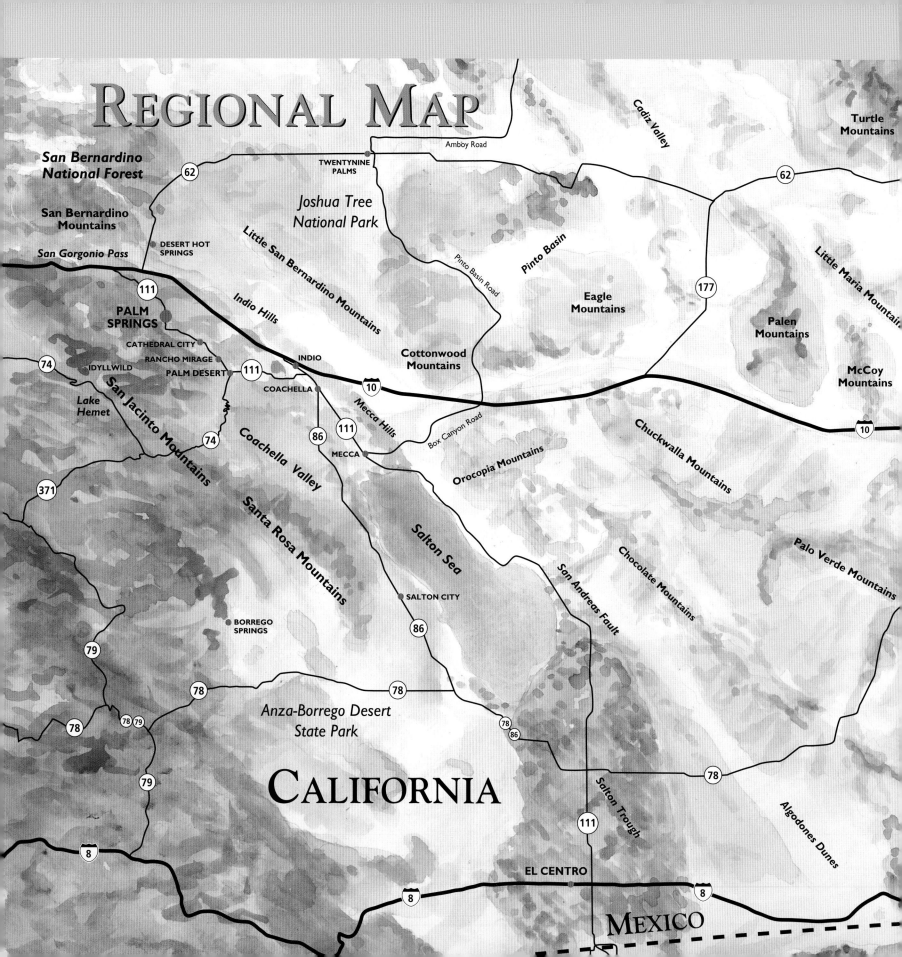

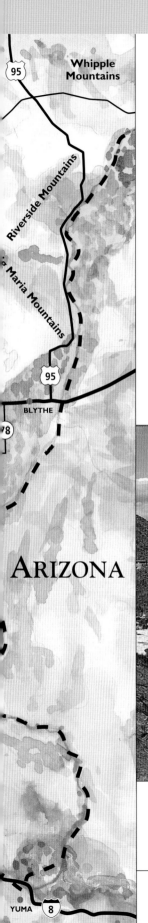

95

Whipple
Mountains

Riverside Mountains

Maria Mountains

95

BLYTHE

8

ARIZONA

YUMA 8

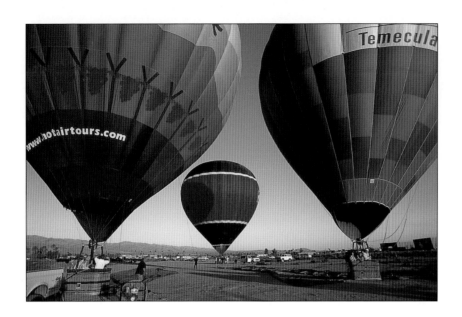

Hot air balloons
Right: San Jacinto State Park

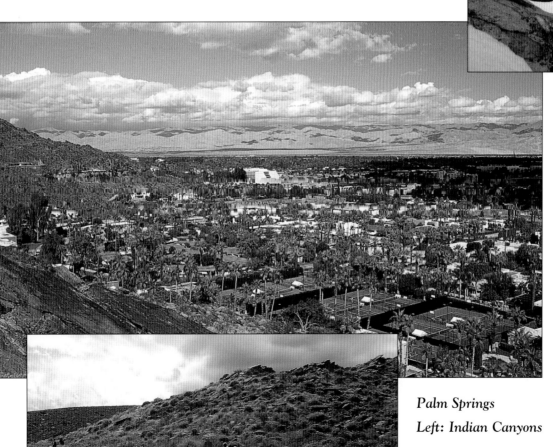

Palm Springs
Left: Indian Canyons

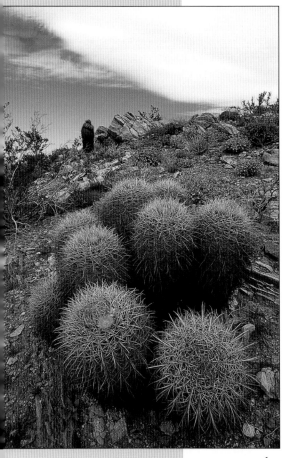

INTRODUCTION

DESERT REFLECTIONS

For most people, the desert is an acquired taste. A typically idyllic vision of nature usually involves a scene with trees, green valleys descending from snowy mountaintops, flowing water, and blue skies with puffy clouds—characteristics rarely found in a desert, and never in profusion. The aspect of nature offered in a desert has much harder edges and rougher textures, where almost everything can hurt you—if not kill you. It demands attention and caution, even under the best circumstances. However, this also may be why it intrigues and fascinates us. We spend our lives trying to be safe and comfortable, and the desert represents a challenge to what we have been taught to do.

Often as interesting as the desert are those who choose to live here full time. A hard place to live must demand a hearty soul. Even so, many who live here do whatever they can to escape the summer heat with air-conditioning, and have to soften the edges by re-creating yards and gardens natural to wetter climes. People have made impossibly barren land productive with irrigation and tamed the habitable places of the desert with frigid air-conditioning. Major cities have grown where once there was but rock and an ironwood tree. The desert is no longer the necessarily demonic land so often portrayed in popular culture. That is, until you stray a few hundred yards away from anything man-made. The character of the desert can quickly re-assert itself and brings you back to the reality that this land must be respected!

The simplest definition of a desert is a region that on average receives less than 10 inches of rain per year. This may not seem like much water, but a few inches will make a major difference in the type of desert before you. Indeed, some deserts can go for many years with no rain at all. And while we tend to associate deserts with extreme heat, this is not always the case. A desert is created by aridity, which can occur in a cold region as well—such as in Antarctica or the Tibetan Plateau. More characteristically, a desert undergoes great extremes of temperature on a yearly, and even daily, basis. There are places where stones can crack or explode as temperatures plummet from sizzling daytime highs to subfreezing at night.

At its heart a desert is all about geology. It is the primal land in a negligee—having the barest of soil or vegetal covering to hide the forces that have been working on the landscape for eons, and so revealing secrets

from deep within the earth. This is a world of rock, with vast expanses open to view and easily accessible to examination. Initially, all that can be seen are rough mountains and barren valleys, but with scrutiny the processes of geology begin to be revealed. Transitions become noticeable where one landform encounters another and blends into it, or where something unique and unexpected emerges as an expression of some unknown force. Patient inquiry raises more observations and mysteries; as one feature becomes understood, another demands a solution. While contemplating the land, you get an inkling of the geological time scale. How incredibly long it must take for that mountain to erode into that valley! That wash is clearly a riverbed, but whenever did it last see enough water to move those striped rocks down its course?

A common reaction to seeing a desert is, "How can anything possibly survive here?" Implicit to this question is the belief that nothing should live here. Your presumptions are exposed, and you may truly come to appreciate the significance of water for life. Once you've accepted the environmental limitations of the desert and acknowledge that existence is in fact possible here, you may begin to define life with a greater appreciation of the myriad designs that have evolved for life forms to persist. Here the line is clearly drawn between the hard physical reality of inorganic matter and the possibility of life at all. You may start to see how your own assumptions color what you believe. The bleaker the desert, the more profound are these revelations.

Perhaps this simple questioning of existence and confrontation with mortality is why deserts have often been seen as places of inspiration, enlightenment, and revelation. Many major religions have references to periods of seeking in a desert, where man can confront his demons and come to understand the significance of his life.

While I have always revered nature as a hiker and camper, my definition of natural beauty was shaped by my previous experiences in the verdure of New England. I was dismayed by the desert, and at first saw it as a wasteland hardly worthy of exploration. It was many years before I even ventured out of Los Angeles to have a look. It wasn't until I went to the desert with someone who loved it that I came to understand it, and began to appreciate this environment. Then I became intrigued and enthralled by this world, and quickly acquired the taste.

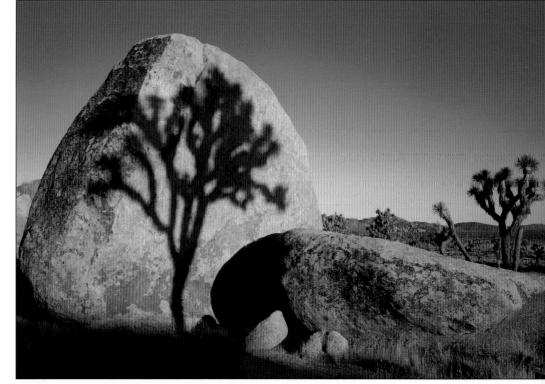

Joshua Tree National Park
Next page: Valley view, San Jacinto State Park

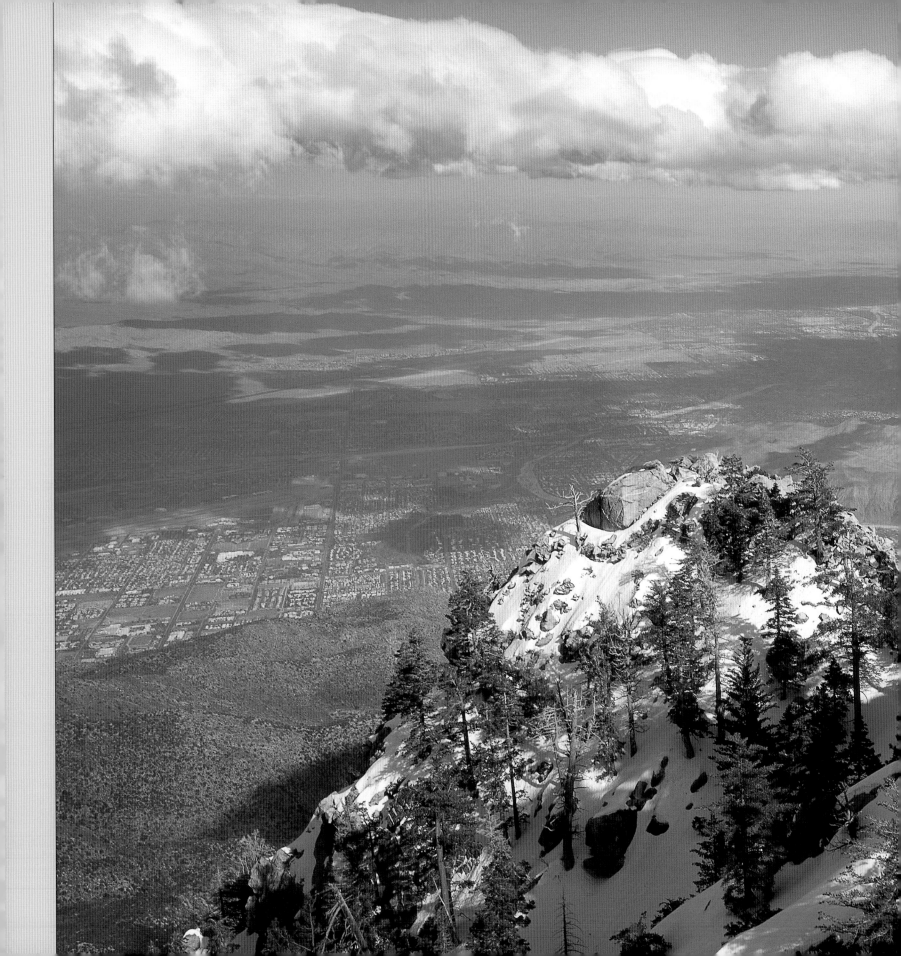

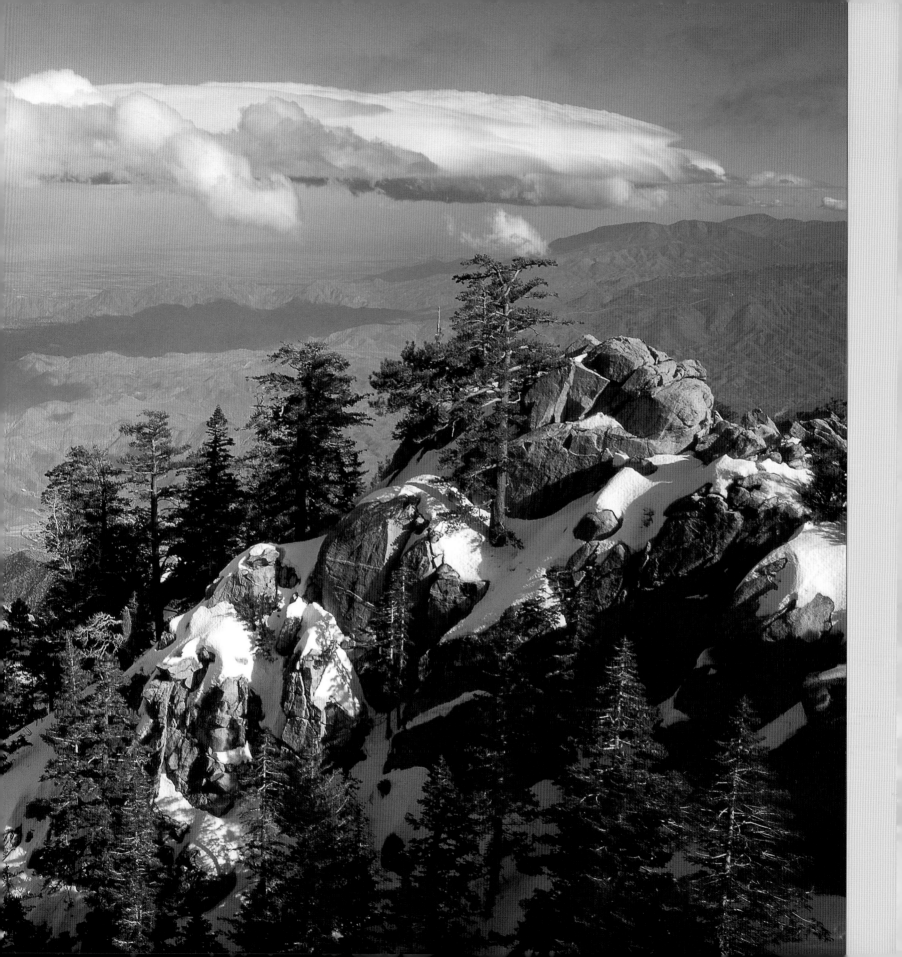

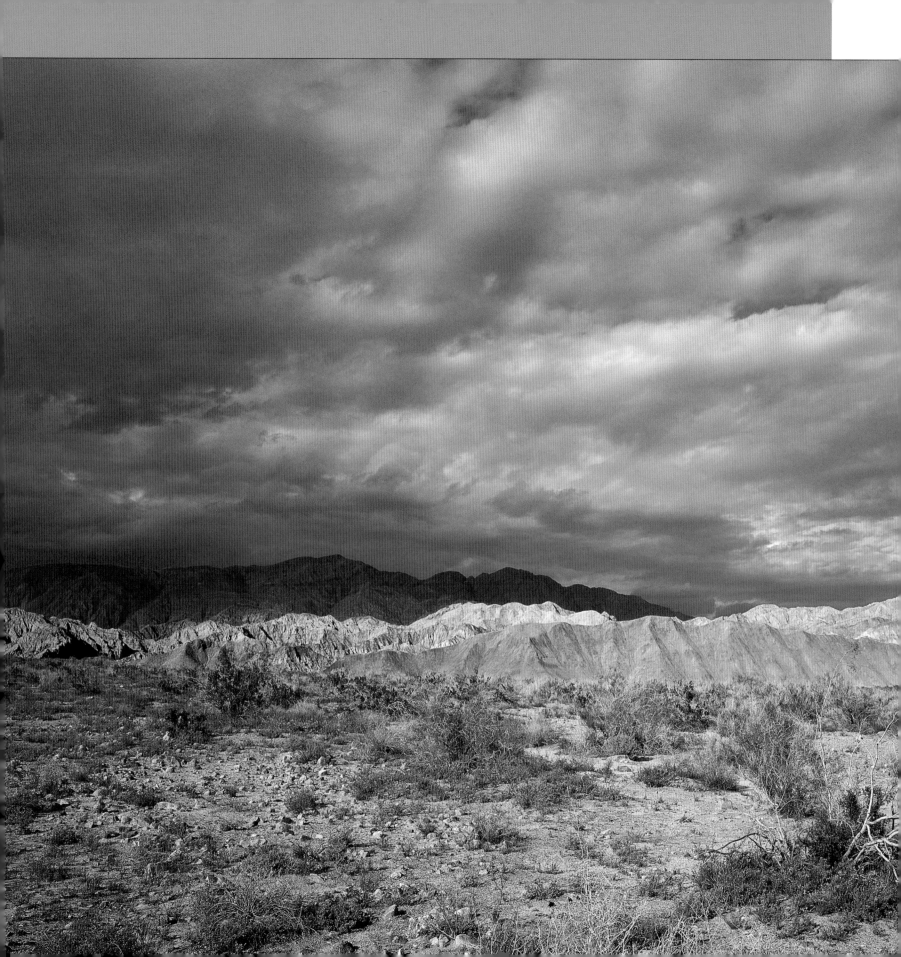

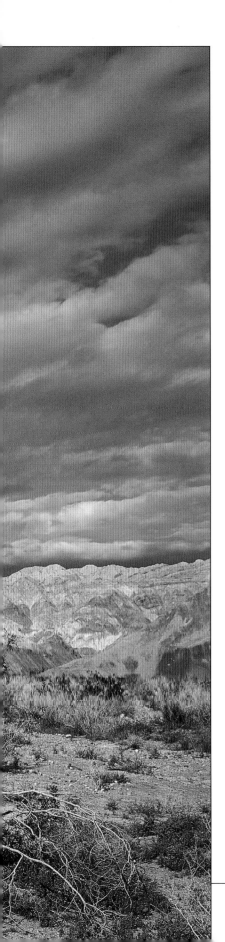

THE COACHELLA VALLEY

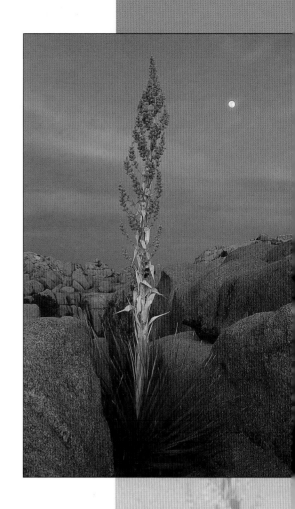

T he Coachella Valley is on the edge of the desert, and unlike the transitions to other ecosystems it has a hard, unsubtle edge. Your entry into it is through a pass that squeezes you through a break in the 10,000-foot-high mountain wall that holds back the moisture of the Pacific Coast. This is the San Gorgonio Pass, where the shift from a Mediterranean climate to a desert one is very noticeable. There can be times in the winter where a virtual mat of wet clouds will hang over the entire state west of the mountains, but barely a tongue of it will follow you through the pass as you emerge from the gloom into the brilliant sunshine of the desert. Since this is the only low point in the mountain wall for hundreds of miles to the north or south, it is probable you will also experience a great deal of wind. According to the

Mecca Hills

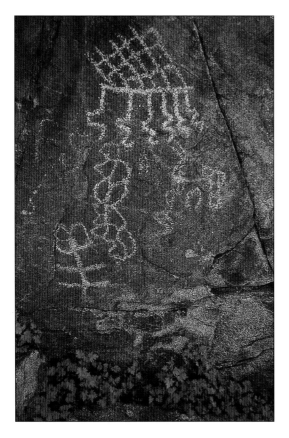

Indian petroglyphs

National Aeronautics and Space Administration, this area is the most consistently windy place in the country, which is the reason for the existence of all the power-generating wind turbines seen within and around the pass. Winter storms, when they make it over the mountains, are brought by the prevailing west wind. However, in the summer unexpected thunderstorms can erupt from the southeast as turbulent moisture-laden air is drawn up from the Sea of Cortez.

The valley measures about 75 by 20 miles, and is located east of the San Gorgonio Pass between the San Jacinto Mountains and the Little San Bernardino Mountains, ending where it runs into the Salton Sea to the southeast. But these simple parameters cannot really convey the nature of the place where this valley exists. To understand it better you have to look at the broader picture.

Here you are at the top of a great rift valley that runs down from the San Gorgonio Pass for over a thousand miles into the Sea of Cortez. About seven million years ago, a long slab of the North American Plate split off along the San Andreas Fault complex and started to move northward with the Pacific Plate. The northern end jammed into a bend in the fault in Southern California, slowing down its motion and causing the mountains of the region to uplift sharply. However, the southern end continued to move, so tectonic forces caused the slab to rotate out into the ocean, thus opening up the Sea of Cortez and creating what is now called Baja California. At one time the ocean came all the way up to the San Gorgonio Pass, and even today would reach Indio if over the last five million years the Colorado River had not deposited more than 10,000 cubic miles of material into its delta. This effectively dammed off the ocean, allowing parts of the Salton Trough to remain dry though they were as much as 271 feet below sea level. At various times the river has changed course, filling the depression with freshwater for long periods, only to change course again and allow the inland sea to dry up. In fact, this valley derives its name from a misspelling of the Spanish word for little shell—conchilla—because of the numerous fossil shells found within its sands that result from this erratic history.

The mountains south of the San Gorgonio Pass raised by this tectonic activity are called the Peninsular Mountains, as they run along the entire length of Baja California. They have created a "rain shadow," which prevents most of the Pacific Ocean's moisture from reaching the inland valleys, thereby creating the deserts of California and northwest Mexico.

The beauty and unique features of this region come from this dynamic geological history, which has included periods of rising magma plutons, volcanism, sedimentation, and metamorphism. Examples of all of these stages often can be seen within relatively short distances. In parts of the Coachella Valley, a ridge of hills runs down the valley's middle, where pressure from the San Andreas Fault has forced up rocks deposited long ago. Elsewhere, eons of persistent winds have blown sands into miles of low dunes. While some remain, most have been covered by the

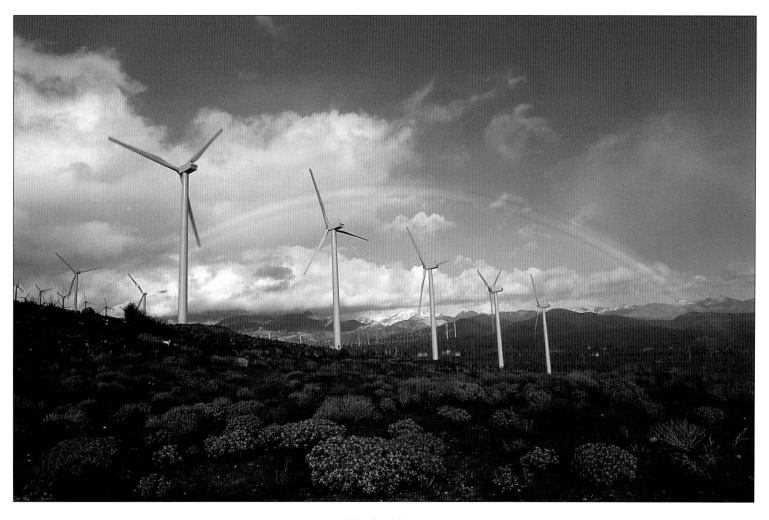

Wind turbines

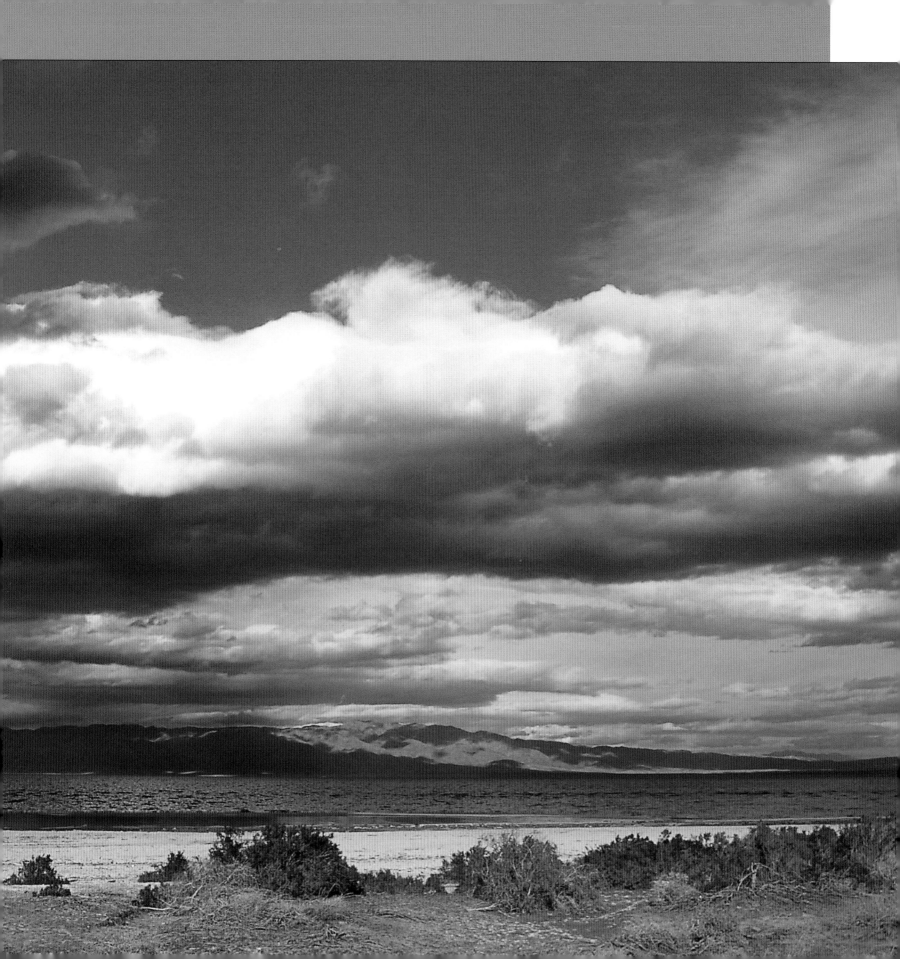

accelerating development of the cities. Farther south past the Salton Sea, the sands have accumulated into one of the largest areas of dunes in the United States.

The San Jacinto and the Santa Rosa mountains run along the southwestern side of the Salton Trough. These mountains are on the slab that was captured from the North American Plate, and are being shoved into the San Bernardinos to the north. The tremendous pressure of this slow-motion collision forced up the two tallest mountains in Southern California, one on either side of the San Andreas Fault. Mount San Jacinto (which rises just behind Palm Springs) has one of the steepest escarpments in the United States, rising over 10,000 feet in just 6 miles to reach a height of 10,804 feet. Just across the rift, San Gorgonio is the taller of the two and reaches 11,502 feet.

On the other side of the Coachella Valley are the Little San Bernardino Mountains, which are an extension of their bigger brothers to the north. Because the slab does not impact them as directly, these mountains have risen only 5,000–6,000 feet. However, they form the separation between the "high" Mojave Desert and the "low" Sonoran Desert (which is also known as the

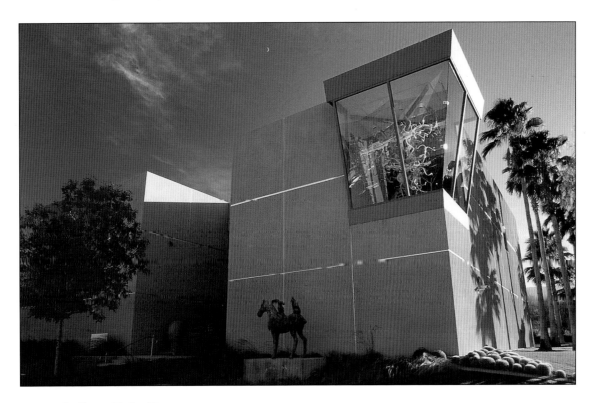

Imago Gallery, Palm Desert
Left: The Salton Sea

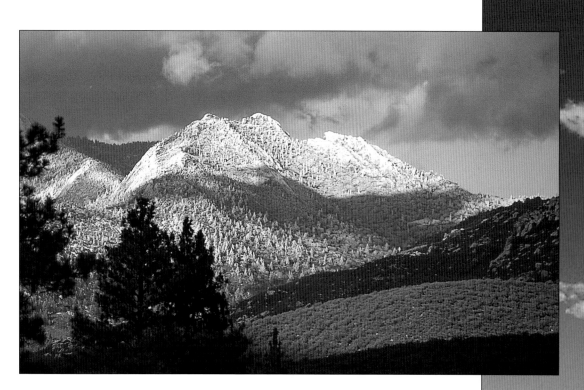

Mount San Jacinto

Colorado Desert). The Mojave is a bit cooler and wetter than the Sonoran Desert, where the Coachella and Imperial valleys are located.

As you might imagine, all this tectonic activity is the cause of the previously mentioned geothermal sites in the region. In a few places such as Palm Springs, Two Bunch Palms, and near Bombay Beach, they have caused heated waters to come to the surface, creating natural hot springs. In other areas such as Desert Hot Springs, the hot waters have been accessed by well. Having always been used by the Indians, these healing waters were quickly embraced by settlers and subsequent visitors to the region.

Right: Palm Springs
Top right: Riverside County Fair

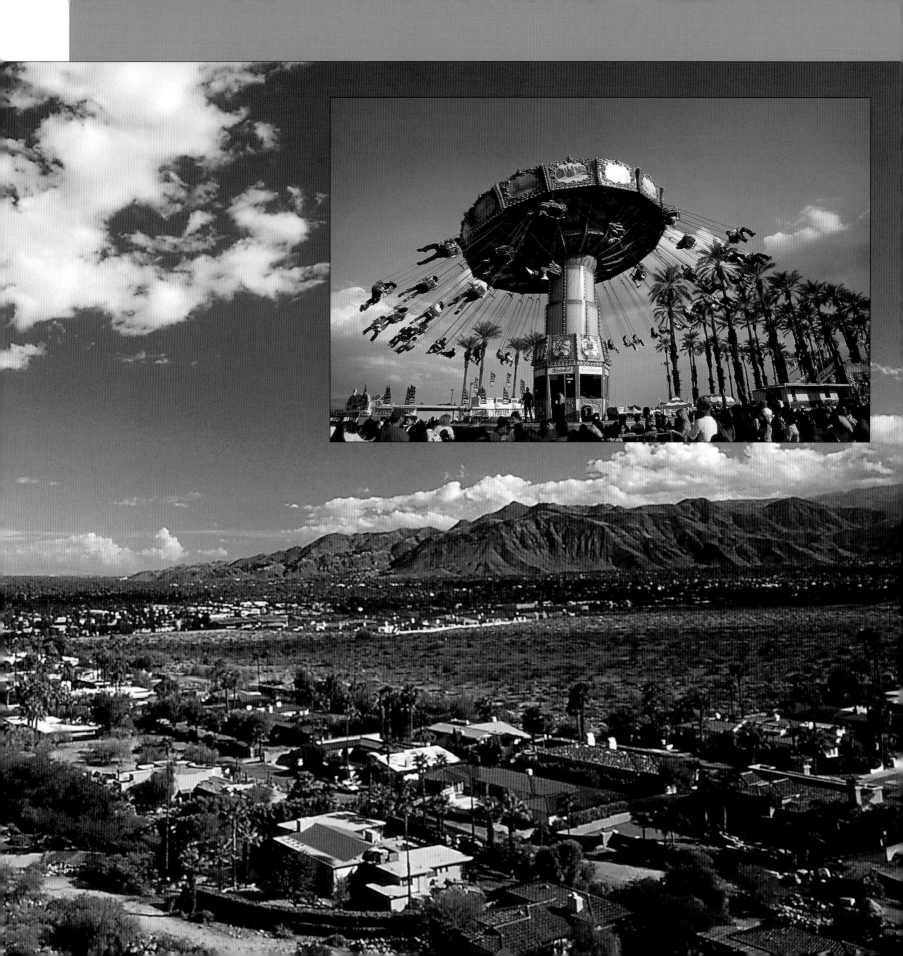

For more than 10,000 years, a number of Indian nations called this region of Southern California home. The Cahuilla, Serrano, Chemehuevi, Kumeyaay, Luiseño, and Cupeño—all of these tribes lived seminomadically in the area, something that only changed with the arrival of Europeans.

At the end of the 16th century, Spanish galleons explored the Sea of Cortez and sailed up the Colorado River as far as Needles. They probed as far as the Imperial Valley but eventually settled only at the top of the gulf. They did not penetrate much farther until 1774, when Juan Bautista de Anza led an expedition to find an overland route from Spain's Mexico to its outpost in Monterey. Two years later he came through with a colonizing party that eventually made its way to Northern California and established San Francisco. His accounts give us our first records of the area and its people. As the Spanish developed missions near the coast in the late 1700s, they labeled all Southern California Indians as "Mission Indians." Because of their distance from the coast, tribes deeper inland did not have to endure as much of the brutality of subjugation, and in fact often provided a refuge for escapees from the mission system. However, when California became a part of the United States, their situation worsened as they lost their land to settlers.

In 1853, professor William Blake led an army survey expedition through the region looking for possible train routes. His group included an artist and scientists who made some of the first detailed descriptions of the region while they established the first wagon route through the valley. In 1877, the railroads came and laid tracks into the valley to

Indian Canyon Golf Course, Palm Springs

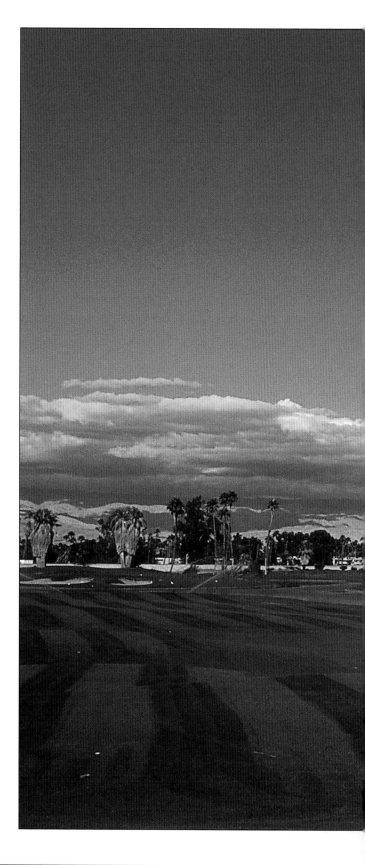

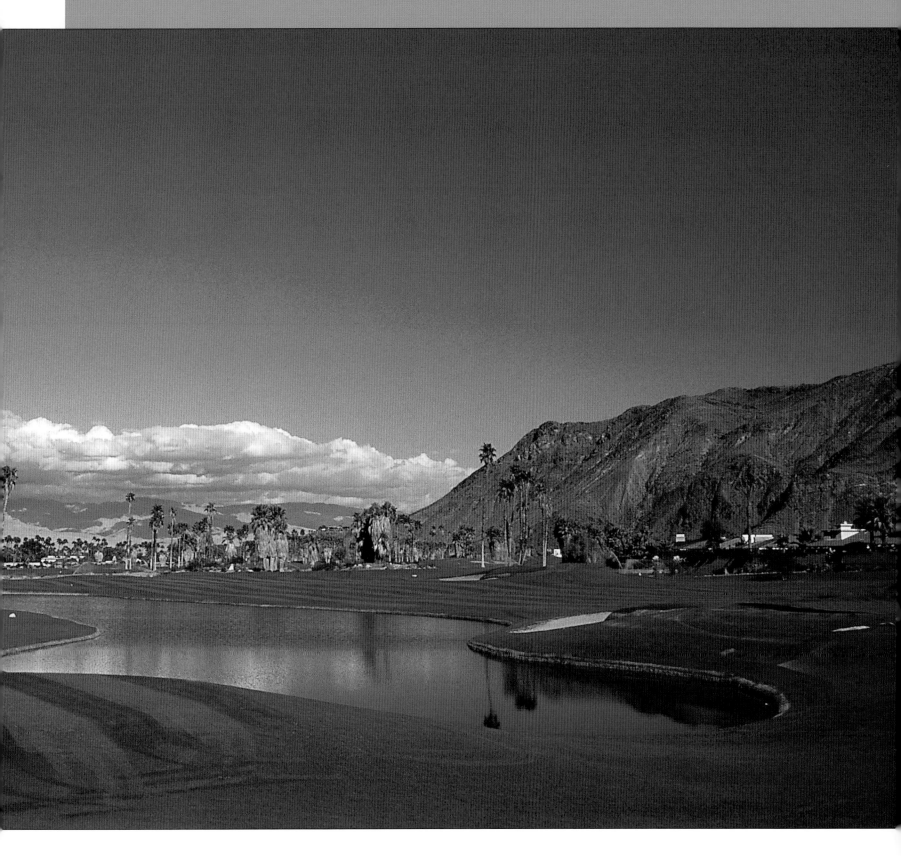

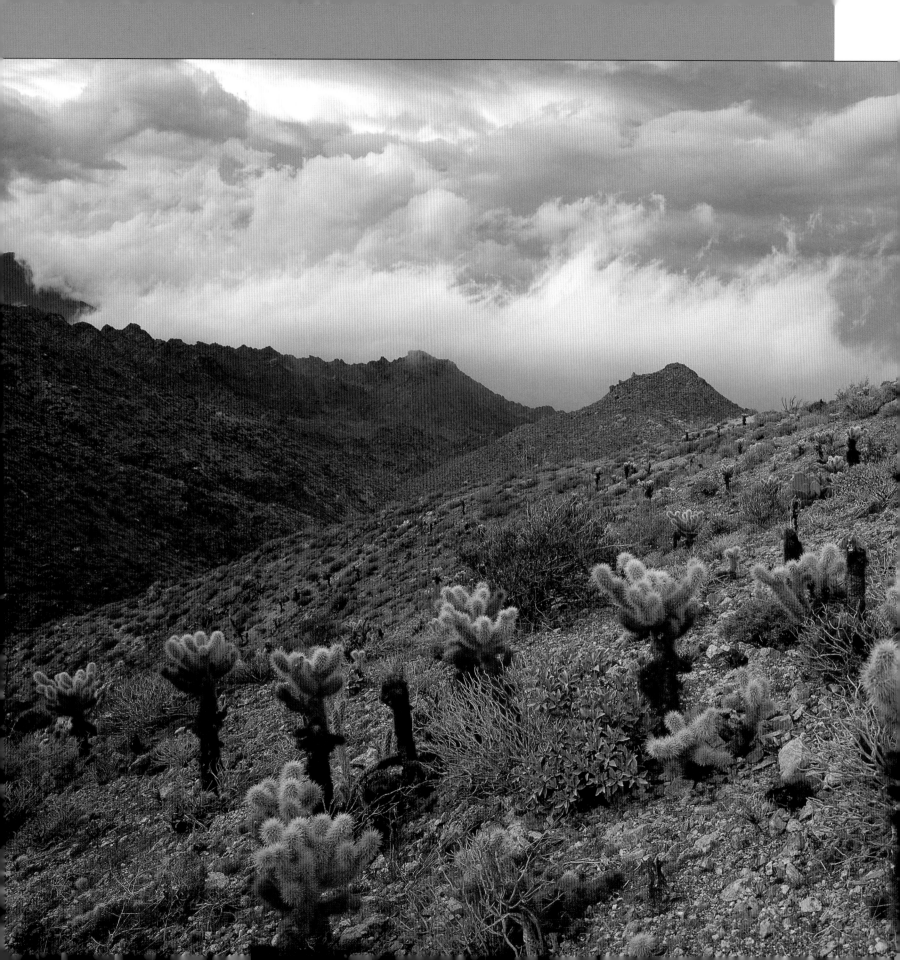

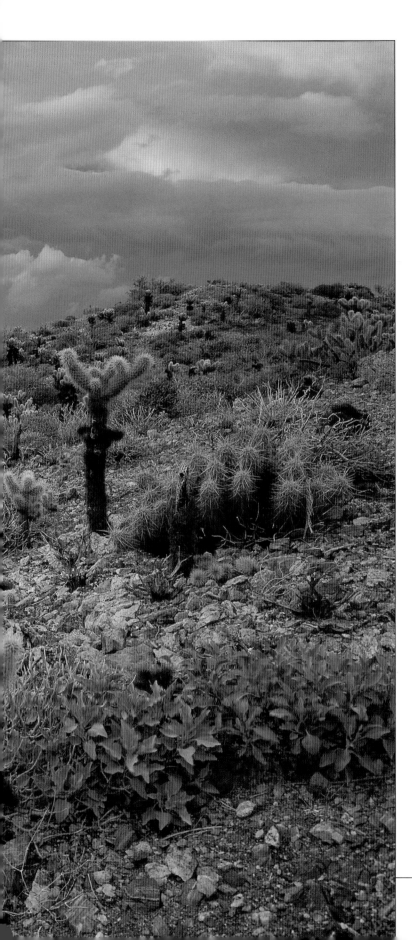

bring settlers from the east. As was common practice, the railroads were granted land from the government that consisted of the odd-numbered sections for 10 miles on either side of the tracks. Later, the government returned some of the adjacent even-numbered sections of land to the Indians, which accounts for the checkerboard pattern of Indian holdings in the valley today.

Remarkably, underneath this seemingly parched land lies a vast aquifer. The railroad companies needed large amounts of water for steam locomotives crossing the southern deserts, and in 1894 they found enough by drilling artesian wells in the Mecca area. Soon afterward, people drilled wells to irrigate the variety of crops emerging in the valley. Towns grew and prospered along the rail line since regional farms could provide produce capable of being shipped throughout the country almost year-round. After earlier failures, dates were successfully introduced as a crop in 1903, and flourished to the point where the region now provides 95 percent of this crop for the entire country. Although there is a great deal of water, it is not enough for the vast orchards, vineyards, and fields that developed over the century—not to mention the golf courses and large communities now spreading down the valley. Therefore, water also is taken from the Colorado River via the All-American and Coachella canals, which were dug from 1938 to 1948.

Carrizo Creek area, Santa Rosa and San Jacinto Mountains National Monument

The Cahuilla Indians revered the natural hot springs here and believed they had magical curative powers. Settlers in the region must have agreed, and by 1870 they erected a public bathhouse on the site. In 1872, Palm Springs became a stage stop on the Bradshaw Trail from Arizona to Los Angeles, and a train stop appeared by 1877. But the first permanent Anglo resident did not settle here until 1884. This was John McCallum of San Francisco, who came seeking a healthy environment for his tuberculosis-afflicted son. His plan to develop agriculture in this part of the valley was defeated with the destruction of his irrigation system by torrential rains, and then a 10-year drought. A reliable source of water for crops was not as available here as farther south, so this end of the valley had to discover another way to succeed.

The first hotel in the area was the Palm Springs Hotel, founded in 1886 by a Scotsman named Welwood Murray. It was not long before more hotels started to house the increasing number of visitors exploring the desert in motorcars. Veterans of World War I with gas-scarred lungs often had the dry desert air recommended to them. This traditional focus on health has continued into the present, with the development of world-class medical facilities such as the Eisenhower Medical Center in Rancho Mirage.

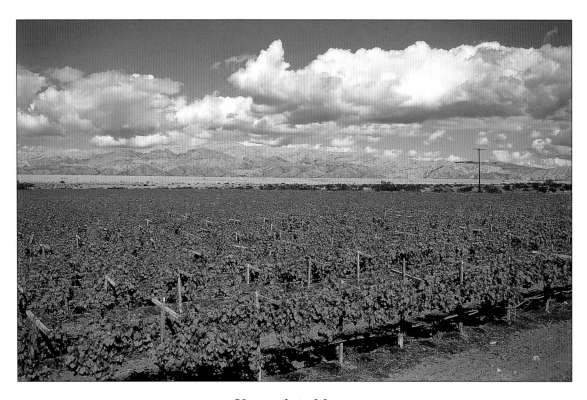

Vineyards in Mecca

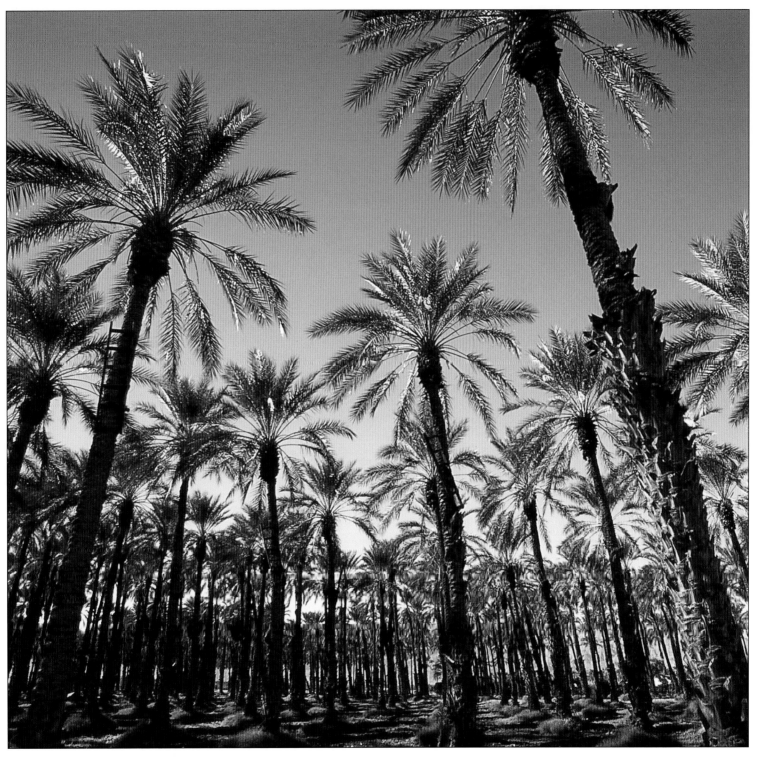

Date palm grove, Indio

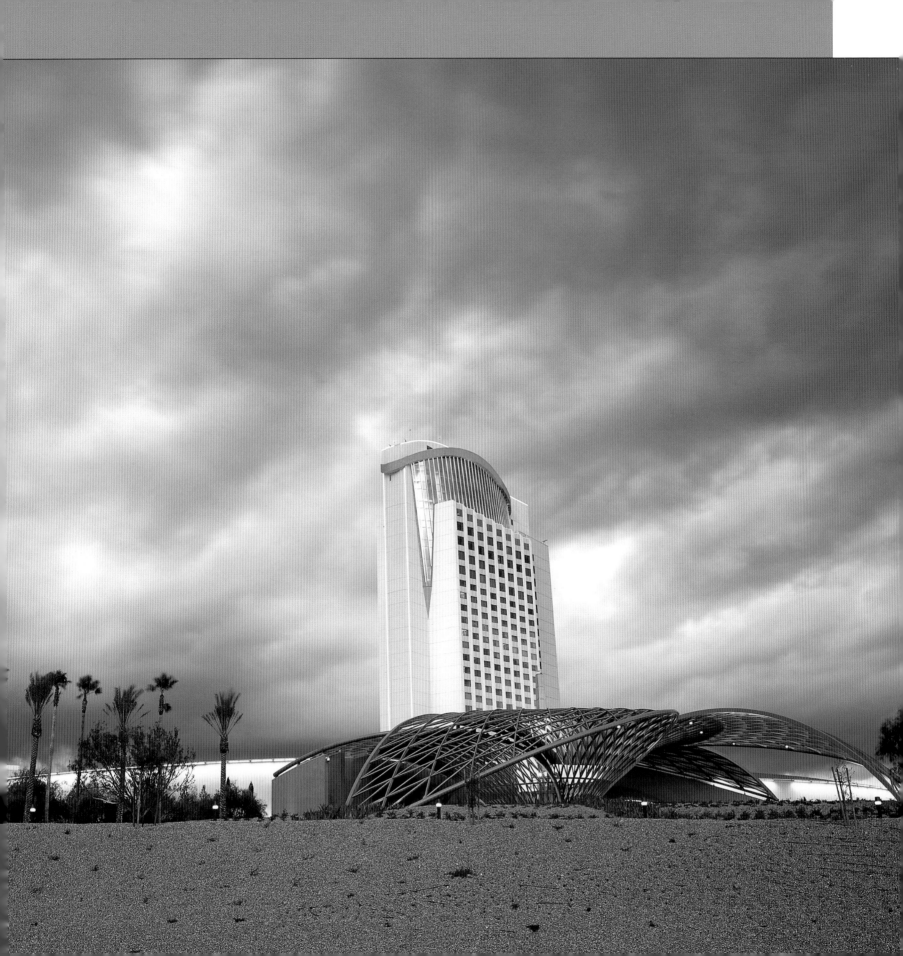

Palm Springs captured the attention of the show-business crowd as early as the 1920s. After World War II, it became a haven for Hollywood stars and many others. In the 1930s, the town developed its first golf course, along with tennis courts and racquet clubs. While agriculture continued to be the focus of development in communities "down valley" such as Indio, the north end became a resort area and a refuge for those wanting to escape the rigors of winter. The hot springs found a new use in relieving the pains of excessive recreation. The original hot springs are located on the grounds of the current Spa Resort Hotel and Casino. Across the valley, Al Capone developed another hot spring into a private compound in the 1920s. This later became the exclusive Desert Hot Springs resort named Two Bunch Palms. Subsequently, wells have been dug here to provide natural hot waters for numerous small motel spas in town. One slope was named Miracle Hill because adjacent wells provide both hot and cold running water.

Palm Springs is more than just a city; it has become an icon of American lore, representing not just itself but the entire Coachella Valley. At first it may seem as if there is but one mini-metropolis in the valley. However, there are in fact nine incorporated cities plus a few unincorporated towns, each with its own unique character.

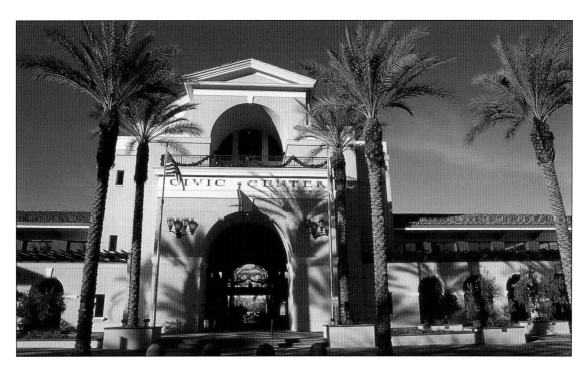

Civic Center, Cathedral City
Left: Morongo Casino

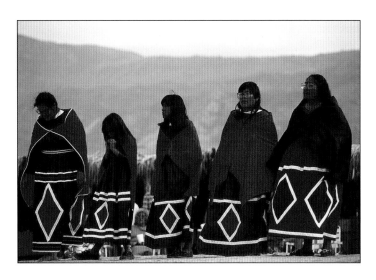

Cahuilla Dancers at the Malki Festival,
Morongo Reservation

Today, this region is often seen as an off-shoot of the Los Angeles area from which it now derives much of its economic base. Historically, however, the area grew as much from the east, with immigrants coming across the southern deserts on foot, in wagons, and eventually with the railroads. From this perspective, the Coachella Valley has a history distinct from Los Angeles.

With about 350,000 inhabitants, the Coachella Valley is the most densely populated area in California's deserts. As this book went to press, the valley was growing at the fastest rate in the state, and was in the second-fastest-growing county in the nation. The valley hosts an estimated 3.5 million visitors every year, with 2 million of them coming to Palm Springs. With the population concentration of the coastal region, people are coming to appreciate the other advantages of a region long viewed primarily as a winter vacation spot.

The area has tried to evolve to provide for the entertainment needs of just about anyone. Hotels here range from the ultra-exclusive to the quaint historic to the seriously rustic. The valley boasts 115 golf courses, many of which are championship level—and more are under construction. The larger hotels offer tennis, or you can go to one of the many racquet clubs. Shopping needs are fulfilled by stores ranging from factory outlets to some of the most exclusive shops in the world. Indeed, the street of El Paseo in Palm Desert easily rivals Rodeo Drive in Beverly Hills.

In terms of entertainment, perhaps what Palm Springs is most noted for is nightlife. This legacy reached a pinnacle with the "Rat Pack" of the 1950s and 1960s, but it lives on with the countless clubs and fine restaurants now found virtually everywhere in the valley. Recently, the nightlife has been augmented with flourishing gaming casinos established on some Indian reservations in the area. Whereas they once only offered gambling, many of these casinos have embraced the "Las Vegas model" and now include spectacular live shows, deluxe accommodations, and resortlike facilities.

I can't imagine anyone becoming bored in this valley, particularly with the large number of celebrations and festivals that occur regularly. Indio prides itself on being known as the "City of Festivals," offering celebrations such as the International Tamale Festival in December, the Desert Circuit of equestrian events for three months in the winter, regular polo matches every Sunday, the Riverside County Fair and Date Festival, and the Southwest Arts Festival in February. Every April, the Coachella Festival —one of the largest rock and contemporary music festivals in the nation—is held on the grounds of the Empire Polo Field.

Between September and June there seems to be an art festival or street fair on almost every weekend somewhere in the valley. And failing that, you can count on Thursday nights on Palm Drive in Palm Springs—when the street is closed down for "Villagefest" and pedestrians, craftspeople, street vendors, and entertainers mingle freely. Numerous powwows occur throughout the valley to reveal the history, culture, and talent of Indians from

Art Affaire, Rancho Mirage

many parts of this country and Mexico. A favorite attraction in Palm Desert is called the Living Desert. This is a combination of a zoo and botanical garden that showcases animals and plants from many of the different deserts around the world. A wide variety of desert plants from the Americas can also be seen at Moorten's Botanical Garden in Palm Springs. When it starts getting too hot and the local pool is just not enough, the Knotts Soak City water park provides a fun way to cool off.

The traditional cultural scene thrives in the Coachella Valley with a variety of museums, countless art galleries, and some notable performing arts venues. The Desert Museum in Palm

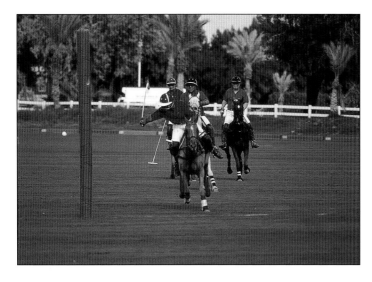

El Dorado Polo Club, Indio

Springs, the daddy of them all, was founded in 1938. This museum has an impressive permanent collection and hosts a variety of visiting works from around the world. The Annenberg Theater, found on the same grounds, presents programs from opera to dance and dramatics. Palm Desert is home to the McCallum Theater for the Performing Arts, which presents just about any kind of show that can be put into a theater. In 1990, the city of Palm Springs began sponsoring the Palm Springs International Film Festival. This event has grown into a major gala affair for the valley every January. A number of historical museums here can acquaint you with the region and the people who have lived here. There is even the Palm Springs Air Museum, which has a collection of working vintage airplanes and offers numerous events throughout the season.

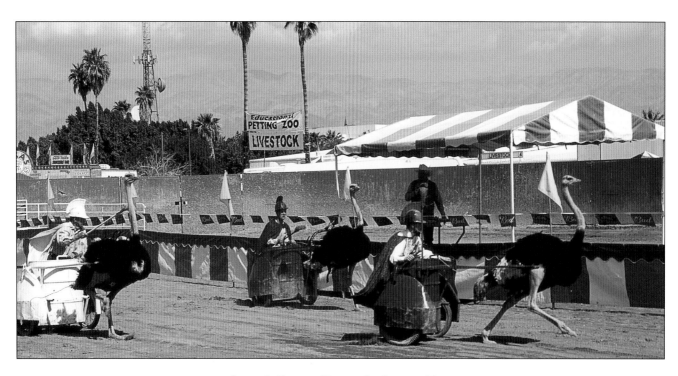

Ostrich Races, Riverside County Fair

Sports fans are not overlooked either. Equestrian and polo events are open to the public in Indio, as are cycling tours and tennis matches such as the Pacific Life Open in Indian Wells. But in this valley golf is king, with tournaments such as the Bob Hope Chrysler Classic taking place on four golf courses in the valley, the Frank Sinatra Celebrity Invitational in Indian Wells, the Kraft Nabisco Championship in Rancho Mirage, and the Skins Game in La Quinta.

All considered, there seems to be something for every taste in this burgeoning region that prides itself on being able to satisfy the diverse needs and desires of its residents and visitors. Fortunately almost all of the development that has occurred here has been limited to the valley floor. Most of the mountainous areas were designated as parkland, forest, wilderness, or reservation land early on. As a result, this region also has a wealth of opportunities for the outdoor enthusiast and sportsman. In fact, a deep appreciation for this environment seems ingrained in the people who live here.

Art Affaire, Rancho Mirage

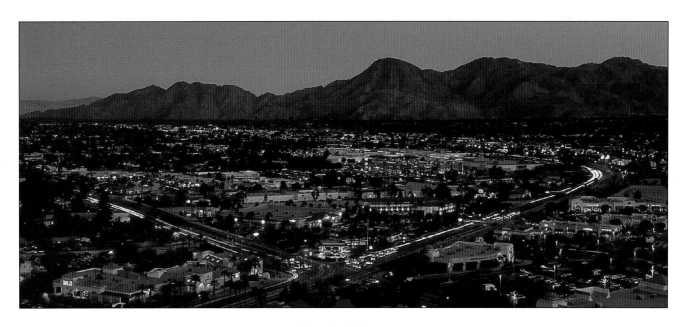

Rancho Mirage
Next page: Palms and dunes, Coachella Valley Preserve

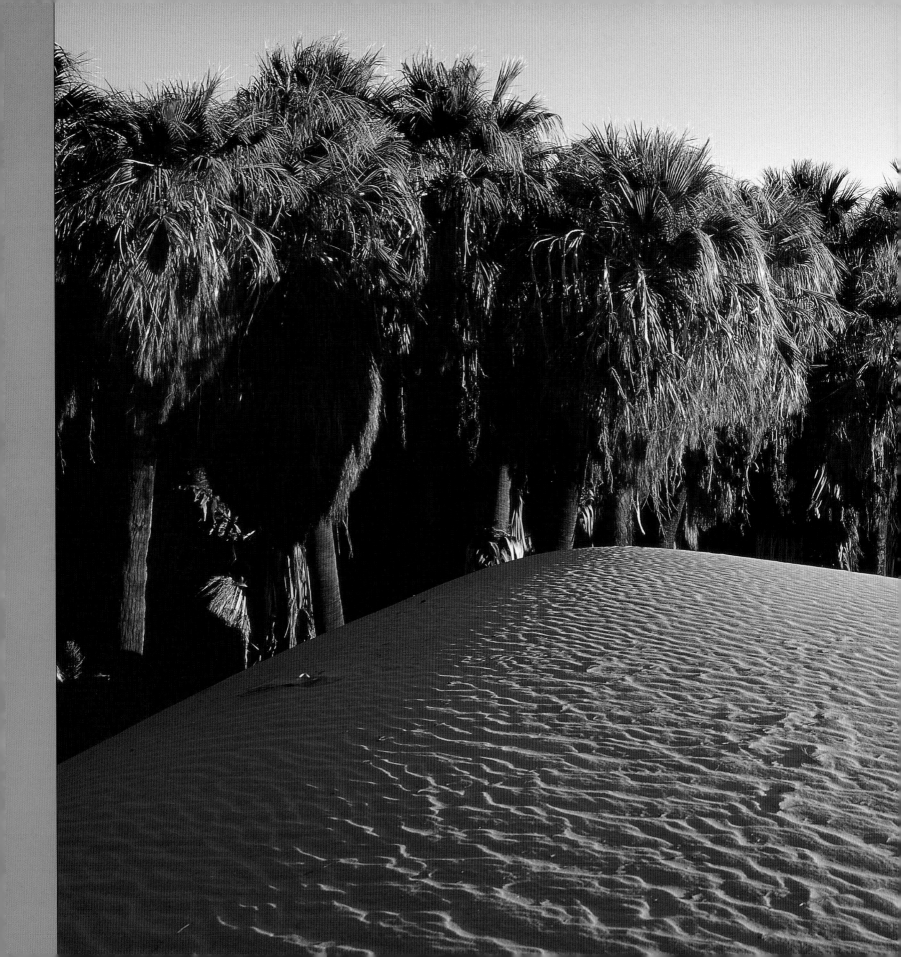

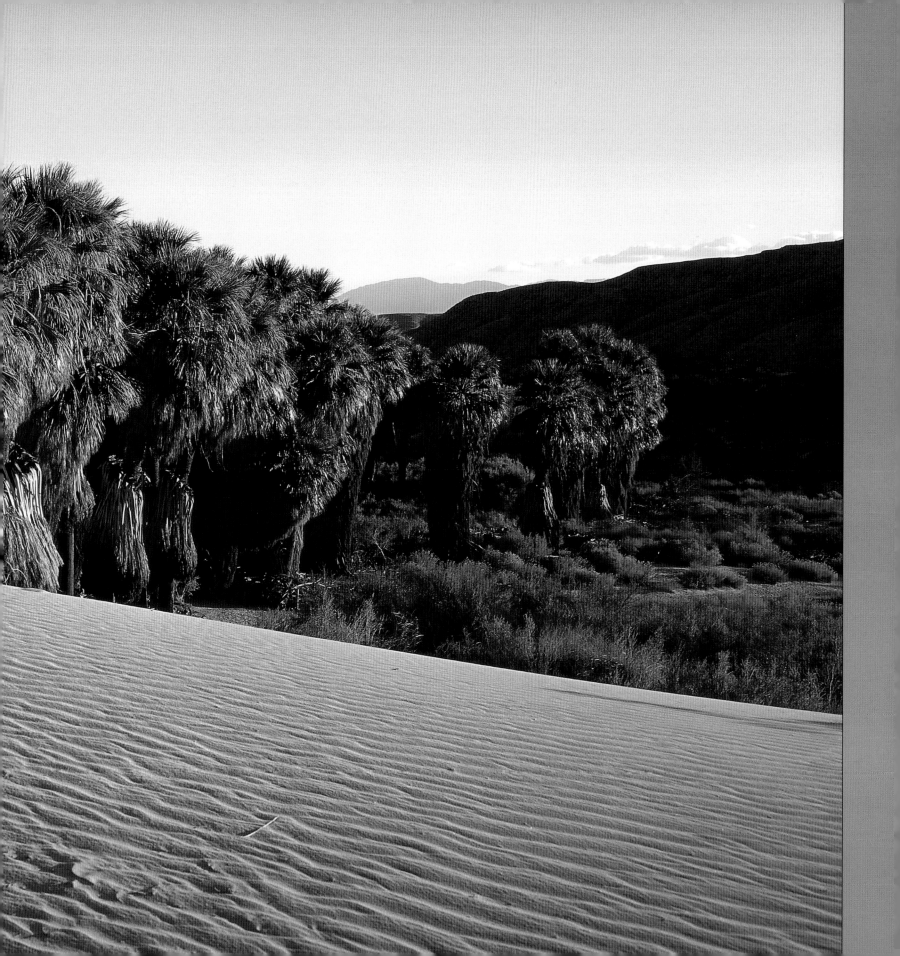

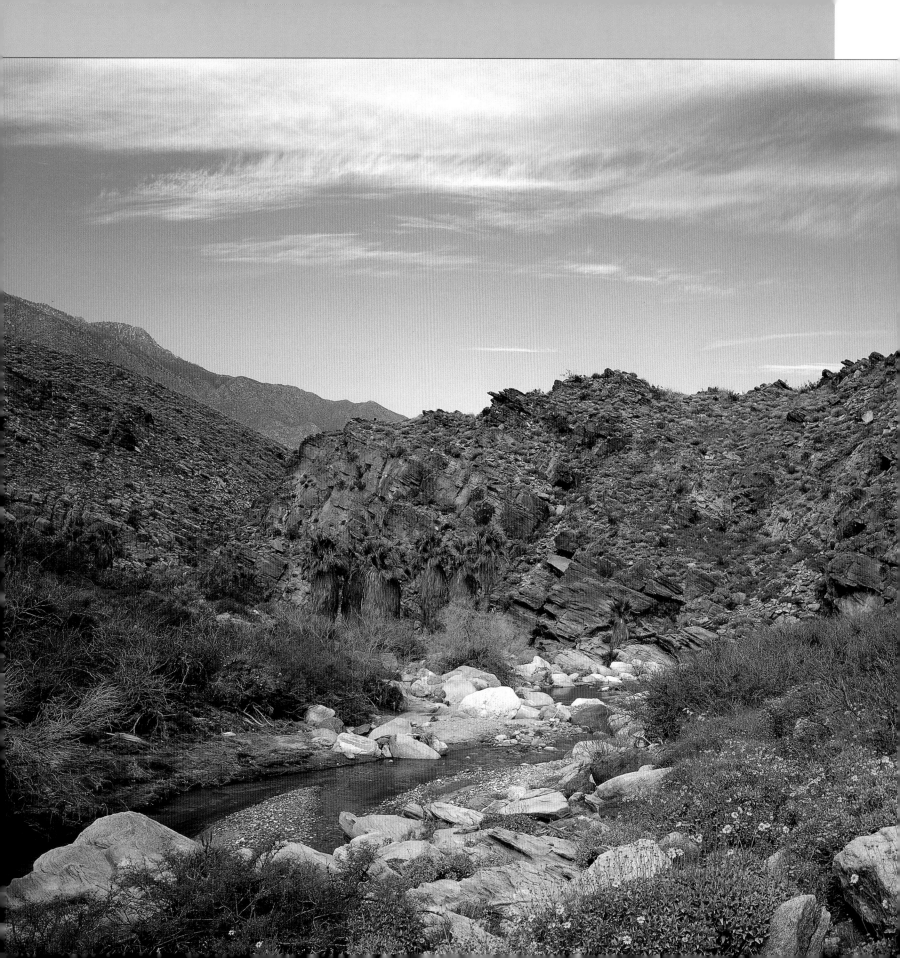

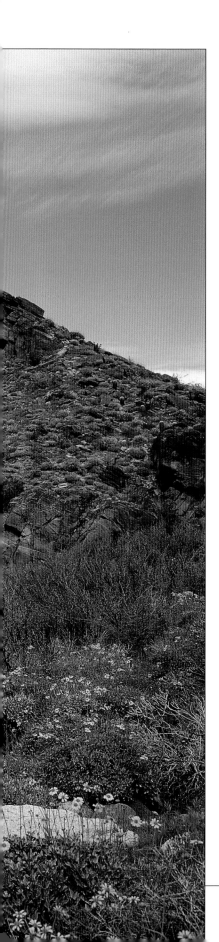

NEARBY NATURE

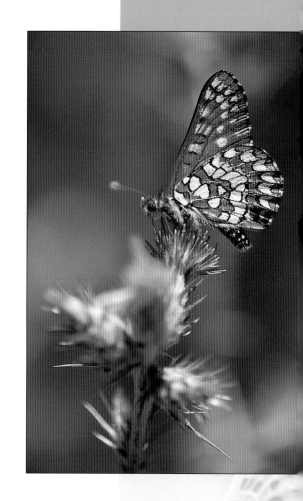

O pen lands start at the doorstep for many Coachella Valley residents, and are readily accessible to all. In most places the development ends where the rock rises into the mountains. For people who live or work in the valley, wilderness is always in view and accessible in a few minutes. With a short drive and a hike you can be startlingly alone thanks to the foresight of the people of this valley, who have fought to keep so much of the surrounding lands preserved.

Most of the eastern slopes of the San Jacinto and Santa Rosa mountains have long been maintained as a patchwork of federal or state designated parks, forests, and wilderness areas, or parts of Indian reservations. In the year 2000, the government consolidated these entities under the joint authority of the Bureau of Land Management and the USDA Forest Service to create the Santa Rosa and San Jacinto Mountains National Monument. This group works in cooperation with the Cahuilla Indians to manage an unbroken swath of wilderness from the San Gorgonio Pass to Anza-Borrego

Fern Canyon Trail, Indian Canyons

Desert State Park, which is 50 miles away. A remarkable aspect of this monument is that it ranges in altitude from just a few hundred feet above sea level to over 10,000 feet. As a result, a great diversity of habitats can be found within the 272,000 acres, which cover five distinct climactic zones. Access by road into the monument is limited, but there is a network of hiking and riding trails.

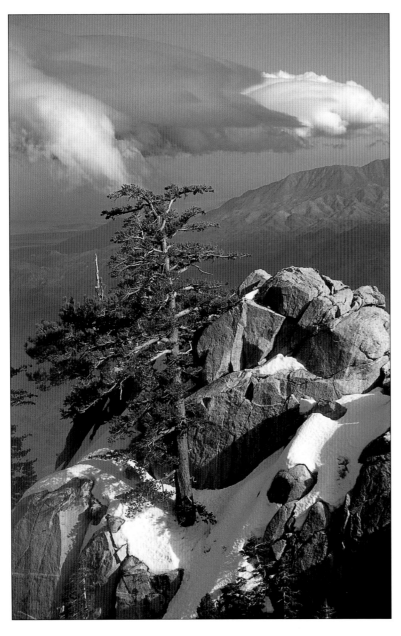

Tree on peak, San Jacinto State Park

Behind Palm Springs are four canyons that cut into the base of the mountains. As a part of the reservation of the Agua Caliente Band of Cahuilla Indians, they are collectively known as the Indian Canyons. For thousands of years the Cahuilla established their primary communities in the mouths of these canyons due to their reliable water supply. Artifacts of their habitation such as petroglyphs, bedrock mortars, house pits, and the like are still seen in the canyons. Today, they are home to some of the largest natural palm oases in the world. Palm Canyon is the longest, and follows a gentle grade for 15 miles along the side of the mountains. Andreas and Murray canyons cut more directly into the mountains, creating some dramatic ravines and waterfalls. The steep-walled Tahquitz Canyon empties out right into downtown Palm Springs, and offers an easy hike to an outstanding waterfall. To see water in the desert is always startling, but here the relative abundance of it has created an area of incomparable beauty that supports a wide variety of flora and wildlife—

including bighorn sheep and wild ponies. Hikes along the bottoms of the canyons are remarkable enough, but taking the trails up the sides of the mountains will give you some breathtaking vistas of the mountains and the valley below.

A short drive down the valley will bring you to the Coachella Valley Preserve and Thousand Palms Oasis in the Indio Hills. In this place a section of the original dunes have been set aside to protect the endangered fringe-toed lizard and some endangered plant species. Here you can see what much of the valley looked like before settlers arrived. Adjacent to the dune area is the low ridgeline of the Indio Hills, hills that the San Andreas Fault raised. In a few places enough underground water has seeped up the fault to create palm tree oases. This 17,000-acre site has a series of trails that can give you the experience of valley-bottom hiking with the occasional refuge of fan palms.

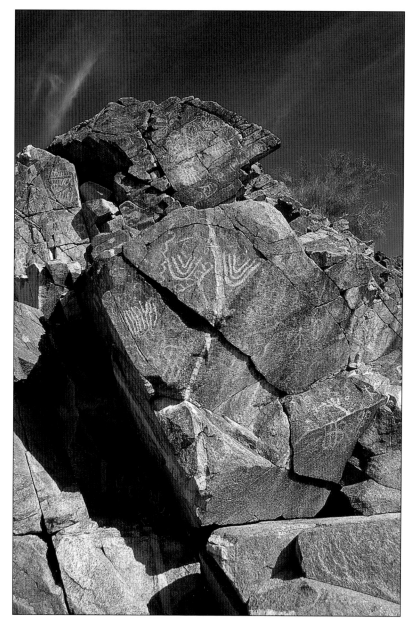

Ancient petroglyphs

On the west side of CA 62 from Palm Springs to the Morongo Valley is a locale once known as the Devil's Garden because of the great amount and variety of cacti that used to be found there. Unfortunately, in the 1920s desert gardens became fashionable in Los Angeles, and people uprooted nearly all of the cacti to satisfy the sudden demand for fully grown plants. This vicinity is actually part of the foothills of San Gorgonio Mountain. At the northern end of the terrain is the

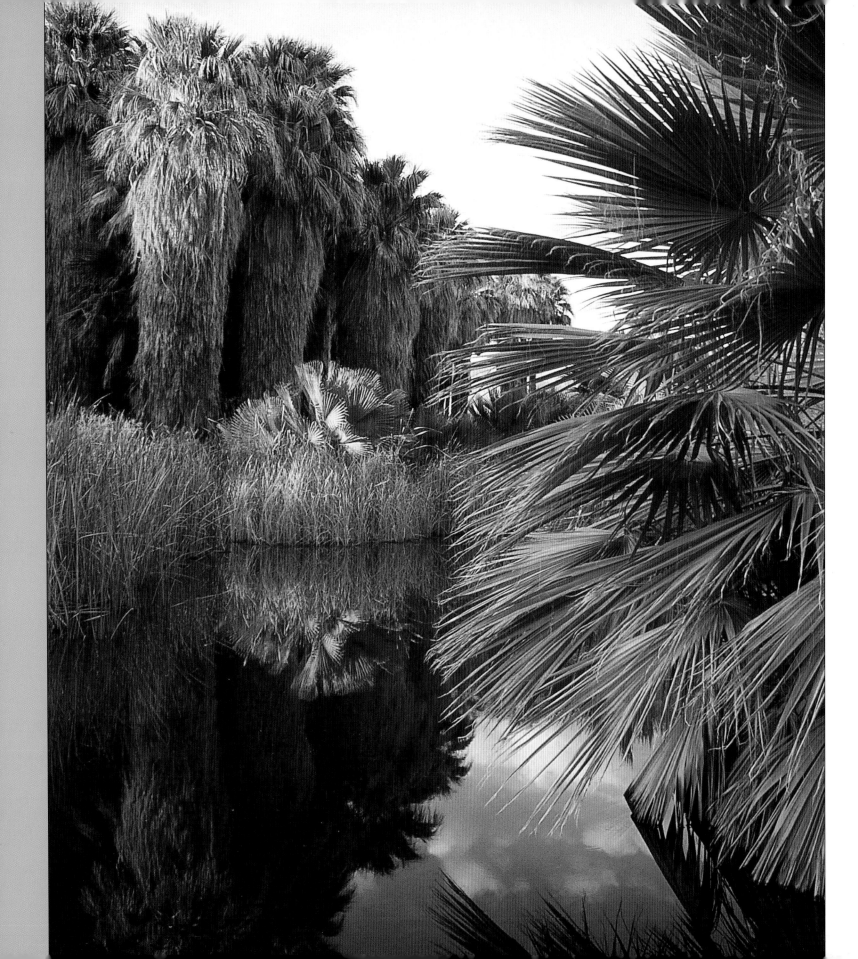

Mission Creek Preserve. Mission Creek drains water from the slopes of San Gorgonio Mountain, going down through the Mojave Desert and into the Sonoran Desert. A hike up this watercourse will reveal a mixture of flora from both deserts, and eventually will bring you to a lush wetland. This conservancy manages more than 40 square miles of land in this region, including the Pipes Canyon Preserve a bit further north. These two areas maintain important habitats that link the slopes of San Gorgonio Mountain with the desert below for both wildlife and people.

Continuing north on CA 62 takes you up through a winding pass into the Morongo Valley. This is the first step up into the "high" Mojave Desert, where lower temperatures and a slightly greater amount of rainfall have allowed different varieties of plants and animals to evolve. Beneath this valley is another fault that has trapped the underground flow of water and forced it to the surface. The water emerges in the Big Morongo Canyon Preserve to create a great

Left: Paul Wilhelm Grove, Coachella Valley Preserve

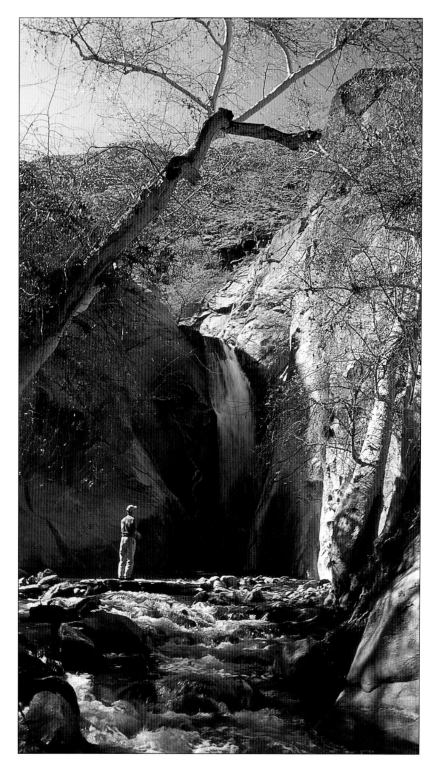

A waterfall in Tahquitz Canyon

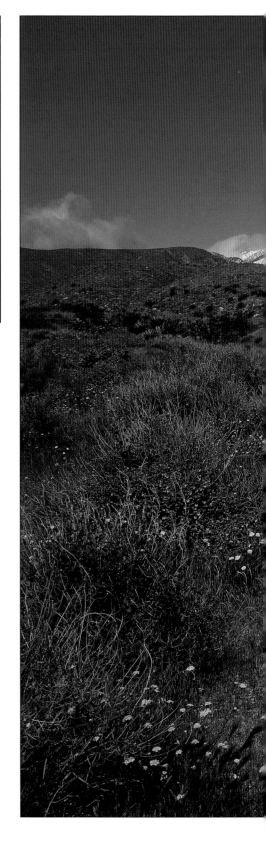

Boardwalk and wetlands, Big Morongo Canyon Preserve

oddity in a desert—marshland. This unique habitat attracts a wide variety of wildlife—especially birds, with more than 240 species sighted. From the marsh, the water drains down the Big Morongo Canyon into the Coachella Valley above the city of Desert Hot Springs. Along the way it creates a riparian habitat filled with cottonwood and willow trees. A series of trails are maintained throughout the preserve as well as an elevated walkway through the swamp area.

Perhaps the most unexpected experience with nature in this region is provided by the Palm Springs aerial tramway. A short drive up Chino Canyon brings you to the base station of a tram that can ascend to the mountain station at an altitude of 8,516 feet in 15 minutes. This is the environmental equivalent of culture shock. In the winter or spring you can be baking in dry desert heat, and then be transported to a snow-covered alpine forest with subfreezing weather within minutes. During the summer or fall, this is a quick and welcome escape from 110-degree daytime temperatures to something in the 70s. You are left at the edge of Mount San Jacinto State (continued on p. 46)

Devil's Garden and San Gorgonio Mountain

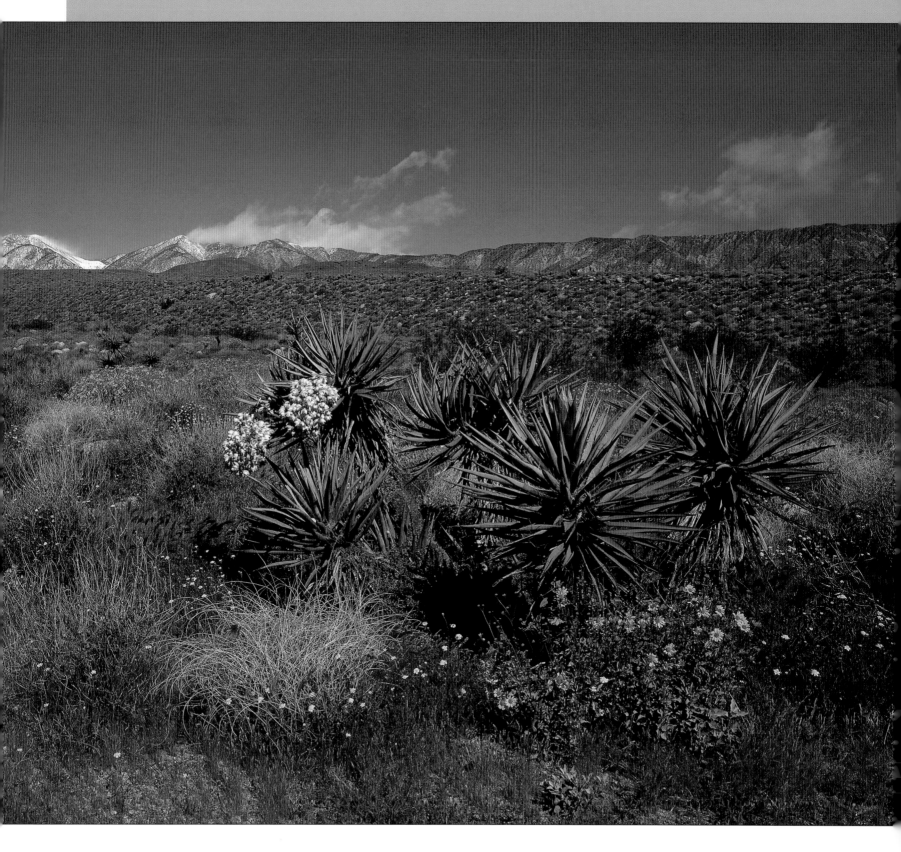

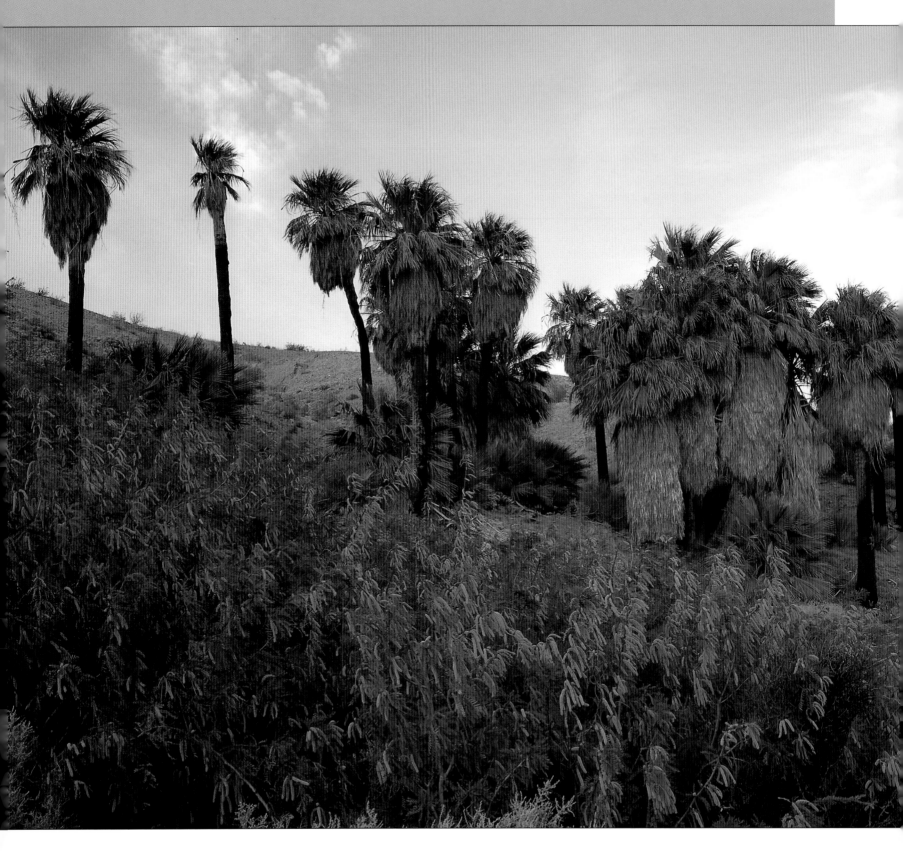

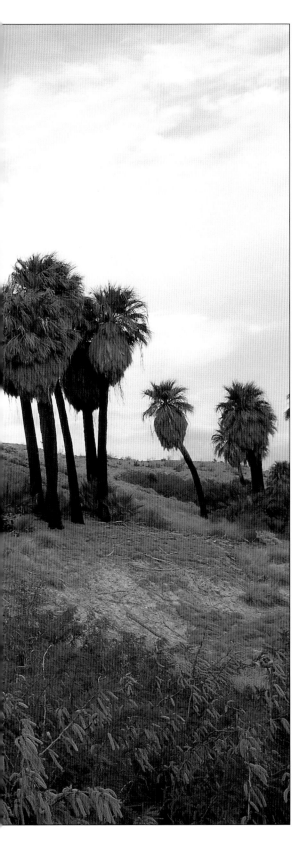

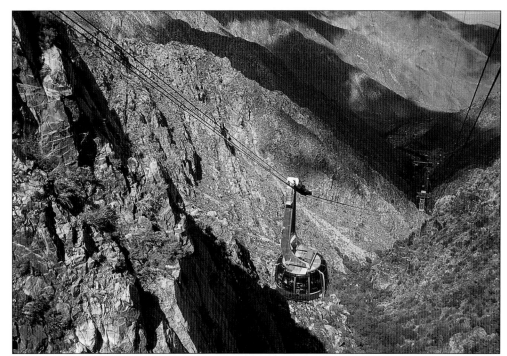

Palm Springs Aerial Tramway

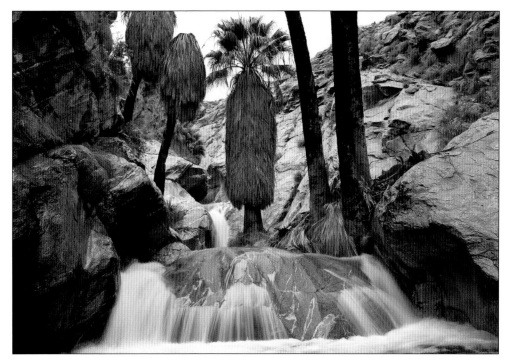

Seven Sisters Falls, Murray Canyon
Left: Mesquite and palms, Coachella Valley Preserve

Park, which has 54 miles of trails within the 13,000 acres of the park and includes a challenging hike to the peak of the mountain. For the less intrepid, the mountain station offers a restaurant, observation decks, and refuge from the cold. Either way a visitor is rewarded with spectacular views of the valley as well as of mountain meadows. This park and some drive-in campgrounds are also accessible via the road on the other side of the mountain, but at a lower altitude.

In addition to areas mentioned here, there are many other city parks, preserves, and natural refuges to be found in the area, each revealing some different facet of the region's environment. You will find that little exploration is required to take you out of the comfort zone of the cities and into a desert land that quickly reasserts its own laws.

The Fern Canyon Trail

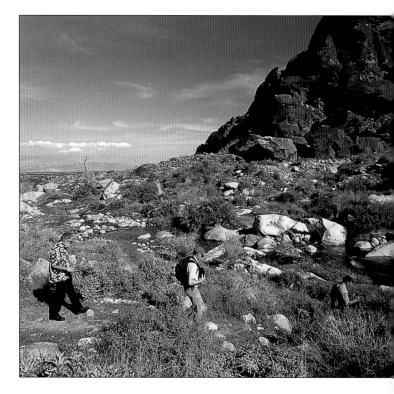

Hikers entering Tahquitz Canyon

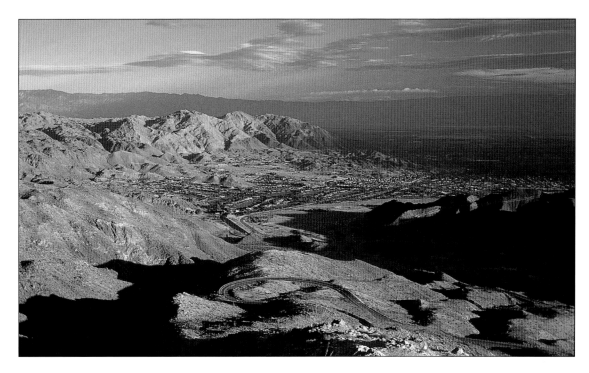

View of Palm Desert

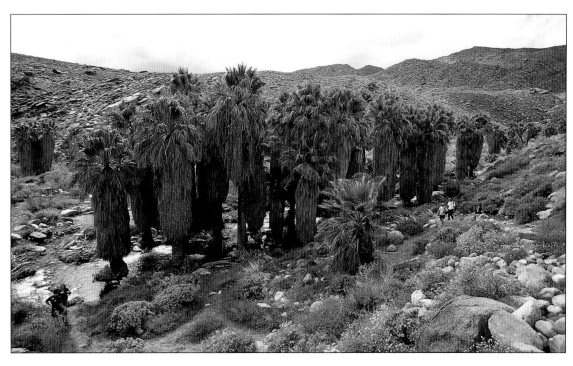

Murray Canyon

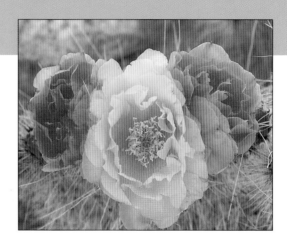

Clockwise (from top left): Double nolina; Joshua tree flower; Bear paw cactus blossoms; Rain-fattened agave

Right (clockwise from top left): Prickly pear fruit; Agave flowers; Calico cactus

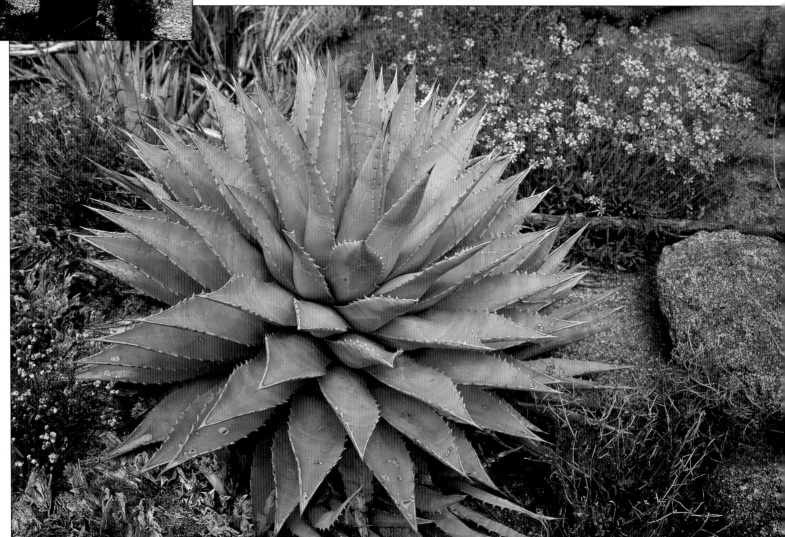

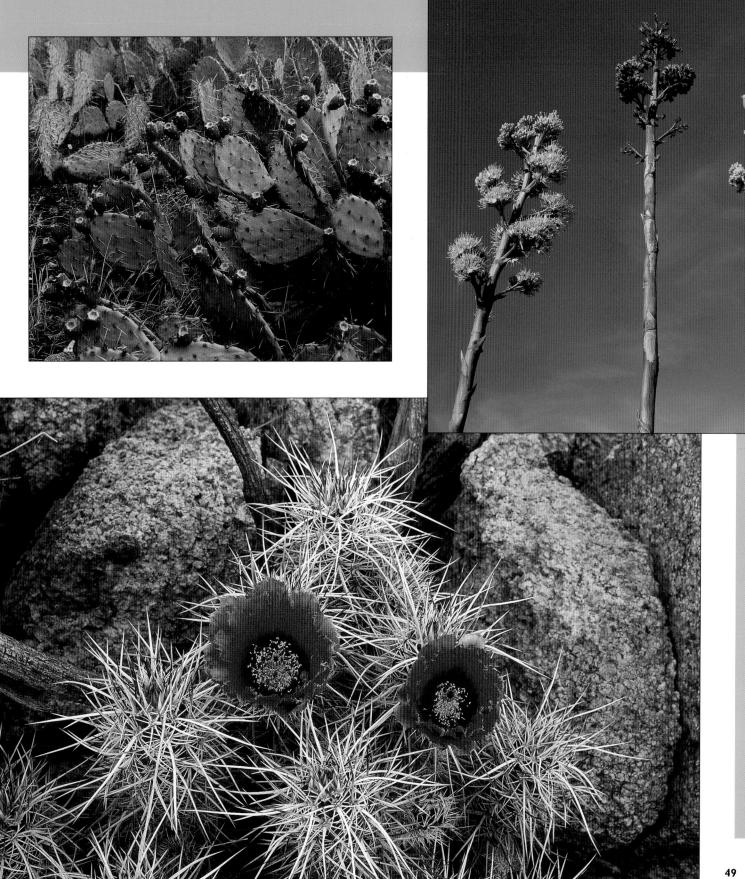

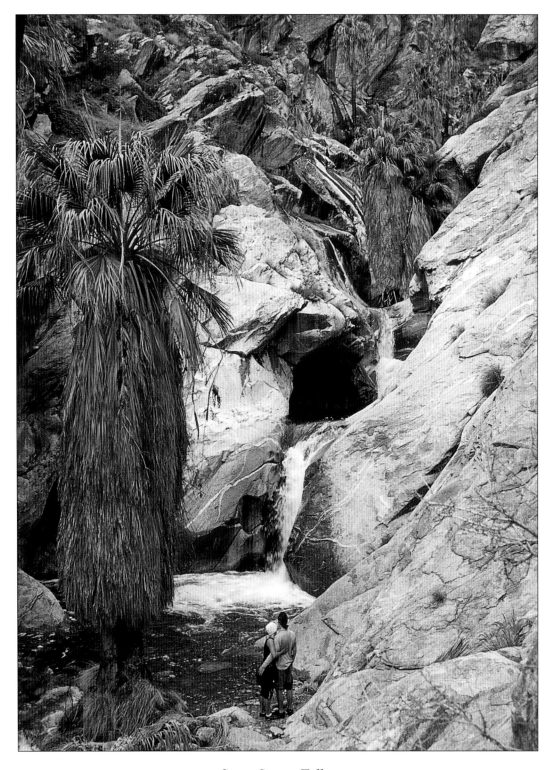

Seven Sisters Falls

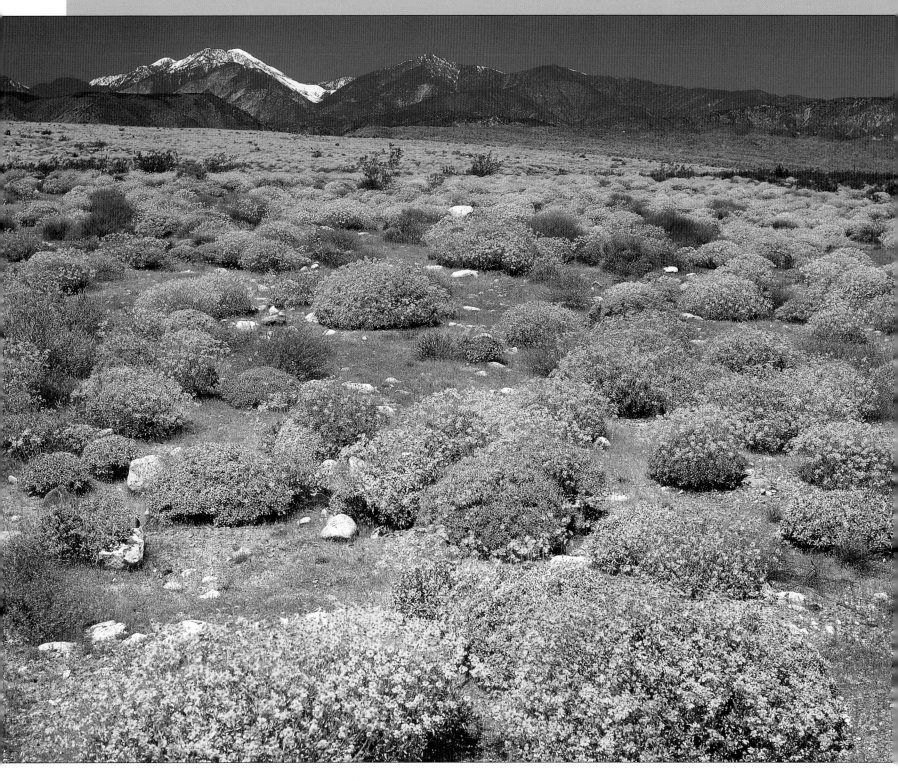

Devil's Garden with brittlebush and view of San Gorgonio Mountain
Next page: Boo Hoff Trail, Santa Rosa and San Jacinto Mountains National Monument

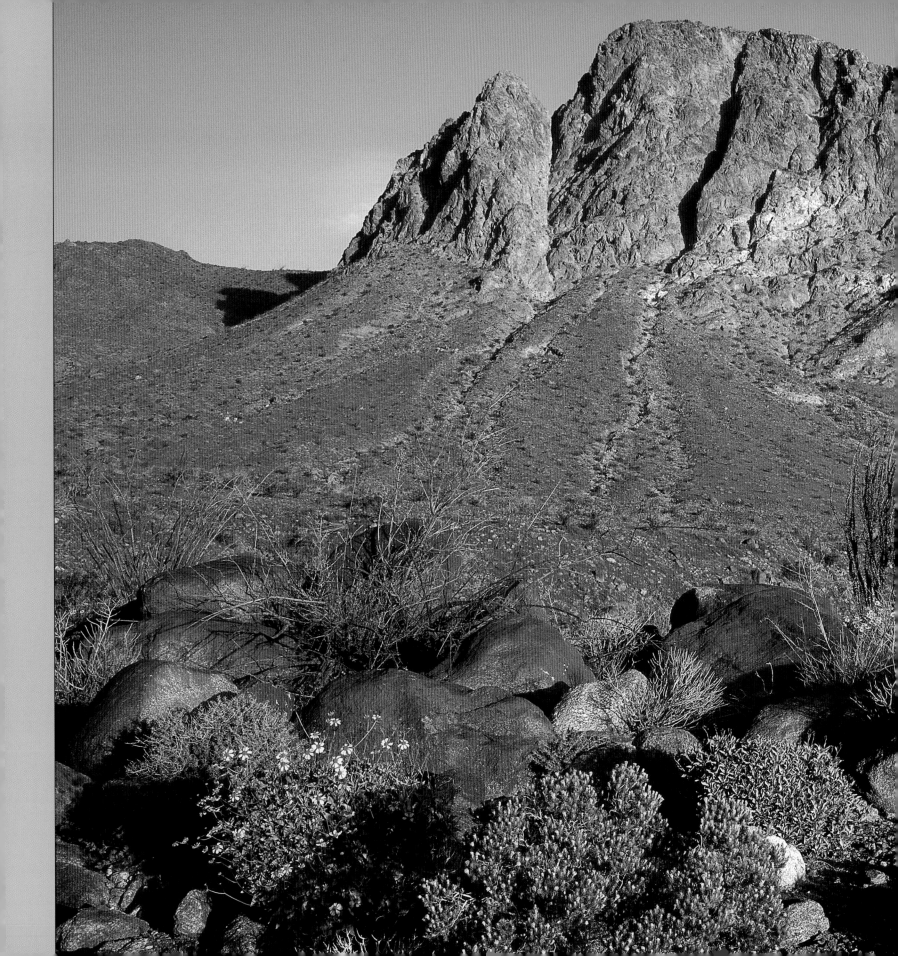

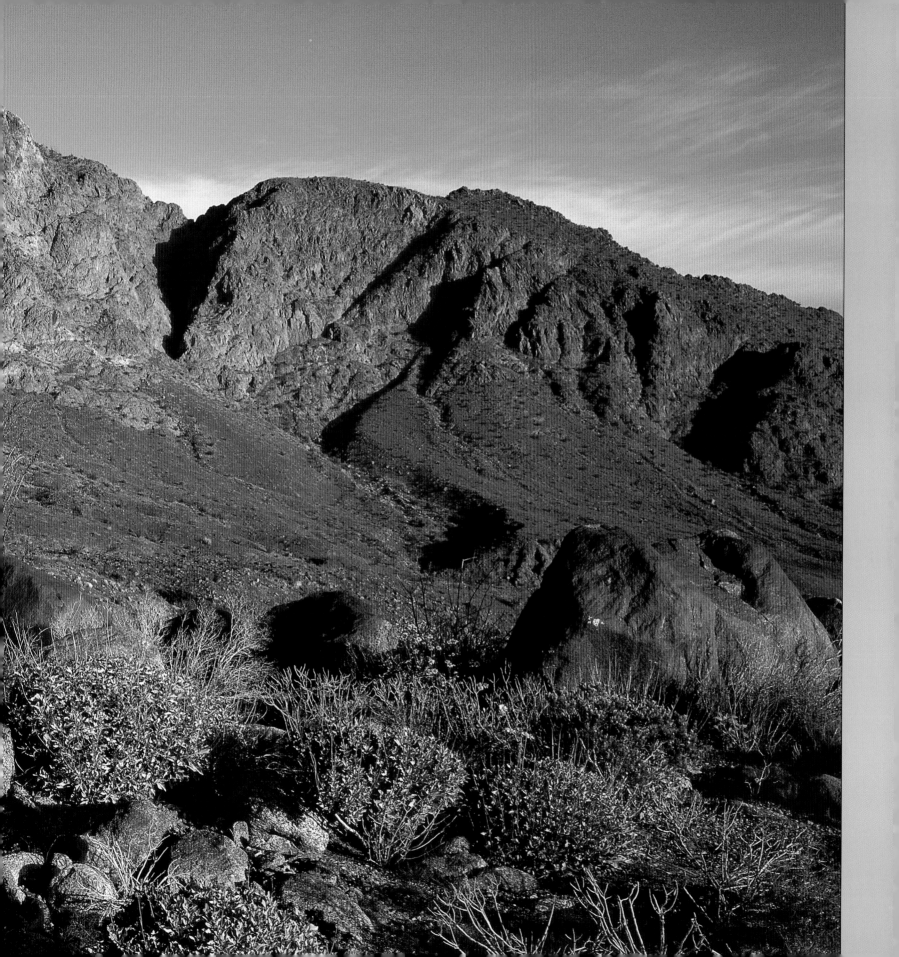

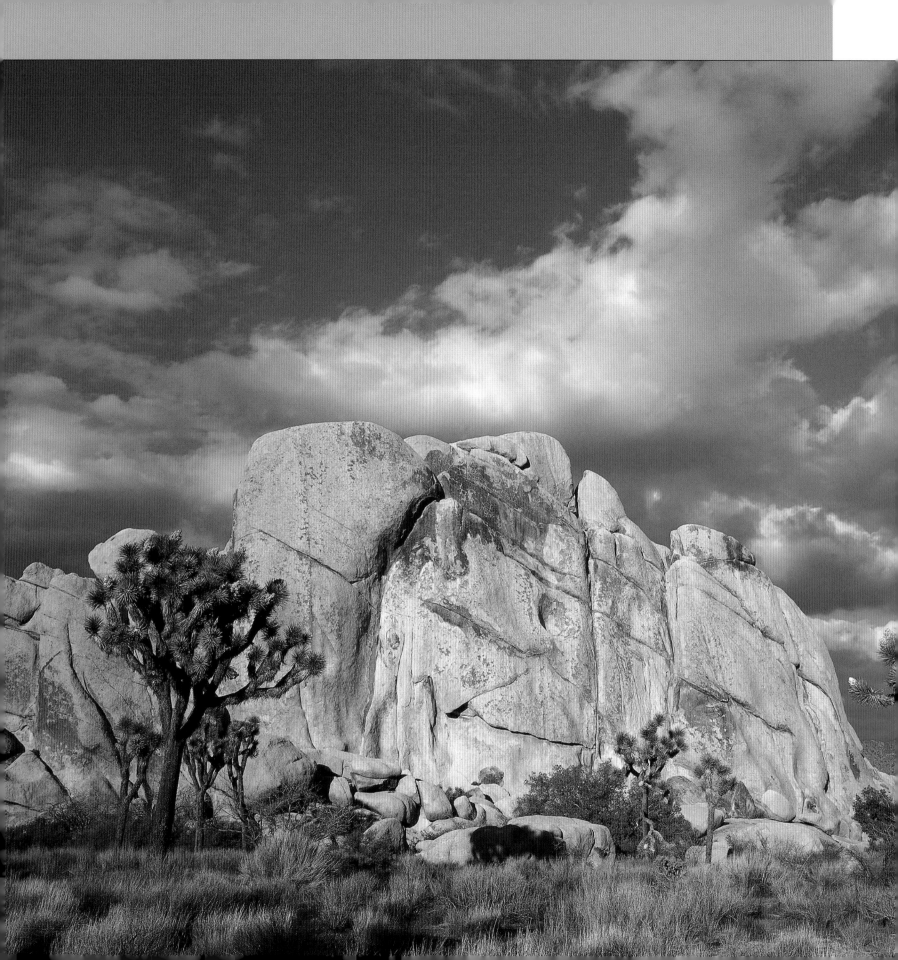

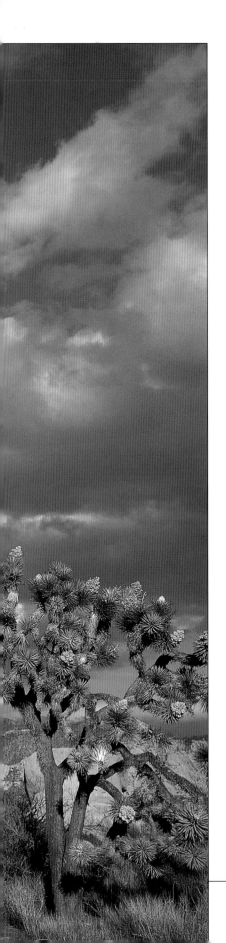

JOSHUA TREE NATIONAL PARK

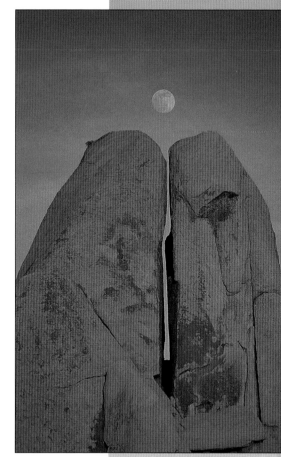

Notrh of the Coachella Valley you can find one of the most remarkable areas of desert in the country. Joshua Tree National Park contains an exceptional amount of geological and biological diversity within its 800,000 acres. This park lies at the eastern end of the transverse ranges and straddles the line between the Mojave and Sonoran deserts, so the elevation ranges from 900 feet to the 5,812-foot peak of Quail Mountain. The unique feature that draws most visitors here is the fantastic scenery produced by hills of huge granite boulders tumbled together in gigantic piles. The rock piles alone provide for some remarkable scenery, but their combination with the oddly shaped Joshua trees can create some truly otherworldly vistas. Additionally, these crags provide exceptional locations for rock climbing. This park is a favored place for climbers (especially in winter), attracting enthusiasts from all over the world.

Old Woman Rock, Hidden Valley Campground; Above: Split Rock

The higher elevation of the Mojave Desert (generally over 3,000 feet) is cooler and wetter than the Sonoran, so the vegetation is more abundant and larger. This is the home of the park's namesake, the Joshua tree. The greater part of the park lies within the more severe Sonoran Desert, where the dominant plant species is the spindly but durable creosote—now believed to be the oldest living plant in the world. Ascending the mountainsides to about 4,000 feet will bring you to another environment, that of the pinyon-juniper forest. In addition to the typical

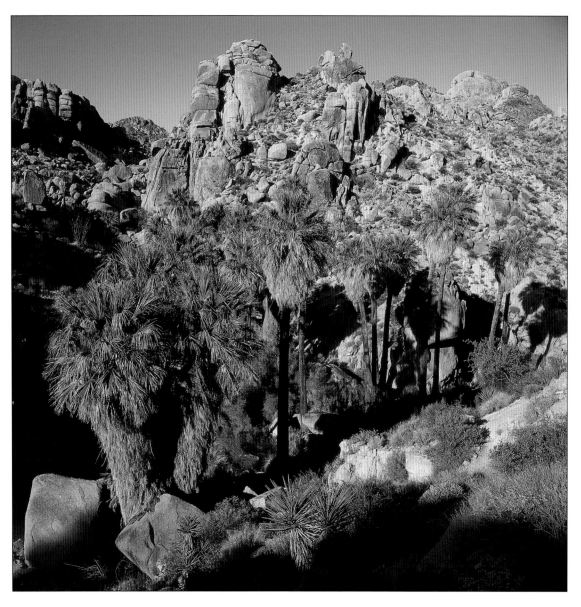

Lost Palms Oasis; Right: Barker Dam

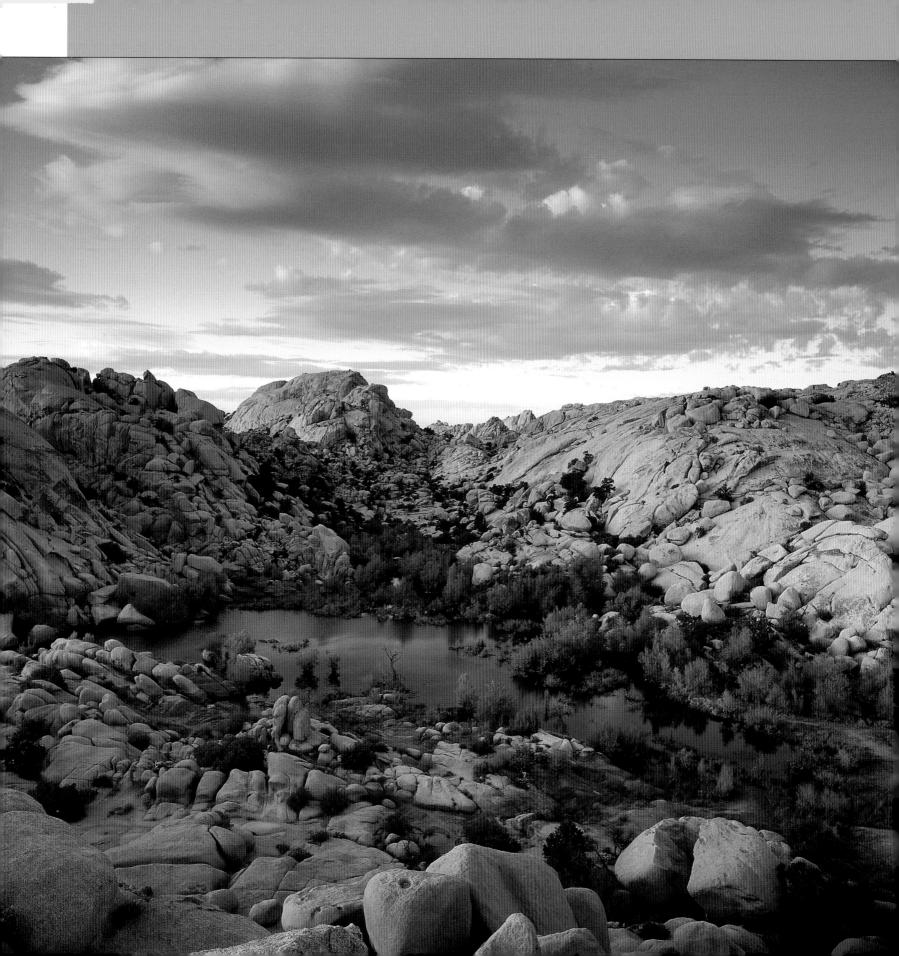

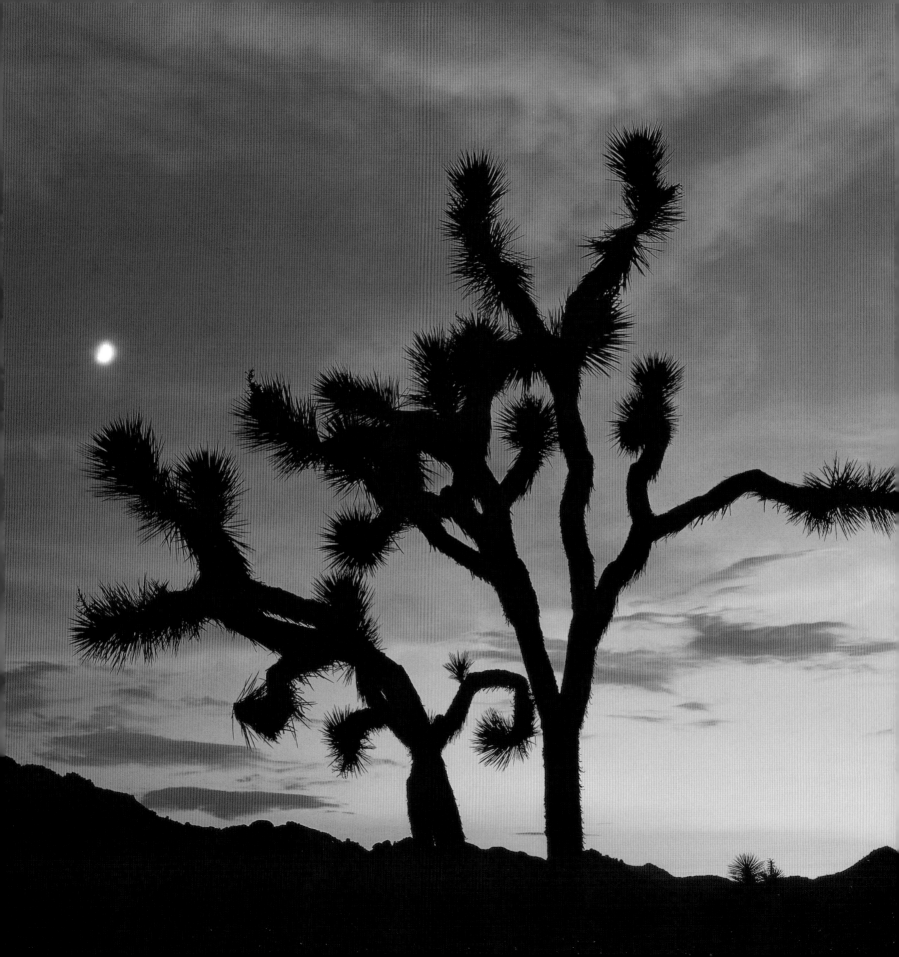

desert habitats, palm oases and riparian gorges can be found in this park. As a result of the diverse environments, a wide range of animals live here—deer, bighorn sheep, mountain lions, coyotes, bobcats, badgers, foxes, numerous small mammals, and a prodigious variety of reptiles and birds.

The Joshua tree is an indicator species of the Mojave, growing only in this high desert at elevations between 2,000 and 6,000 feet. It is the largest of the yuccas, which are members of the lily family. They can grow to 40 feet in height, but since they are not true trees they have no rings by which they can be dated. However, people believe they reach ages of about 300 years. They were given their name by the Mormons, who thought the trees resembled the prophet Joshua beckoning them onward through the desert to their promised land.

The giant rock piles found here are properly called inselbergs and are made of granite originally created 15 miles below the surface. Magmatic pressure forced it to rise up under a preexisting layer of metamorphic rock called gneiss. The tremendous pressure of this squeezing caused the granite to fracture severely. As the land above eroded away over millions of years and the granite bedrock came closer to the surface, groundwater entered the cracks and started a slow process of chemical weathering. The natural acidity of the water softened and broke down any rock surfaces it contacted. So by the time that the granite was exposed to air, the basic shapes of the rock forms now evident were already determined. All that needed to happen was for the loose gravel in the cracks to wash away along with the soil surrounding the rocks as they emerged.

The establishment of Joshua Tree National Park was due to the effort of Minerva Hoyt in the early 1930s. This Pasadena socialite loved the desert and was concerned about the virtual "strip-mining" of cacti that was occurring at the time to fill the gardens of Los Angeles. She established the Desert Conservation League in 1930 and worked tirelessly for the cause of desert preservation, earning her the title of "Apostle of the Cacti." Her work led to the designation of the area as a national monument in 1936, which became elevated to national park status in 1994 as a part of the California Desert Protection Act. Hoyt stated that her concern was not just for the protection of the plants and animals but "to preserve the unique desert atmosphere of silence and mystery."

Maybe this is why 1.2 million people come to Joshua Tree National Park from around the world every year. No doubt they are drawn by an interest in seeing unusual and unique life forms and geology. But perhaps of greater interest is the desire for an experience of mystery provided by the bizarre Joshua trees and unusual rock forms.

Left: Joshua tree at sunset

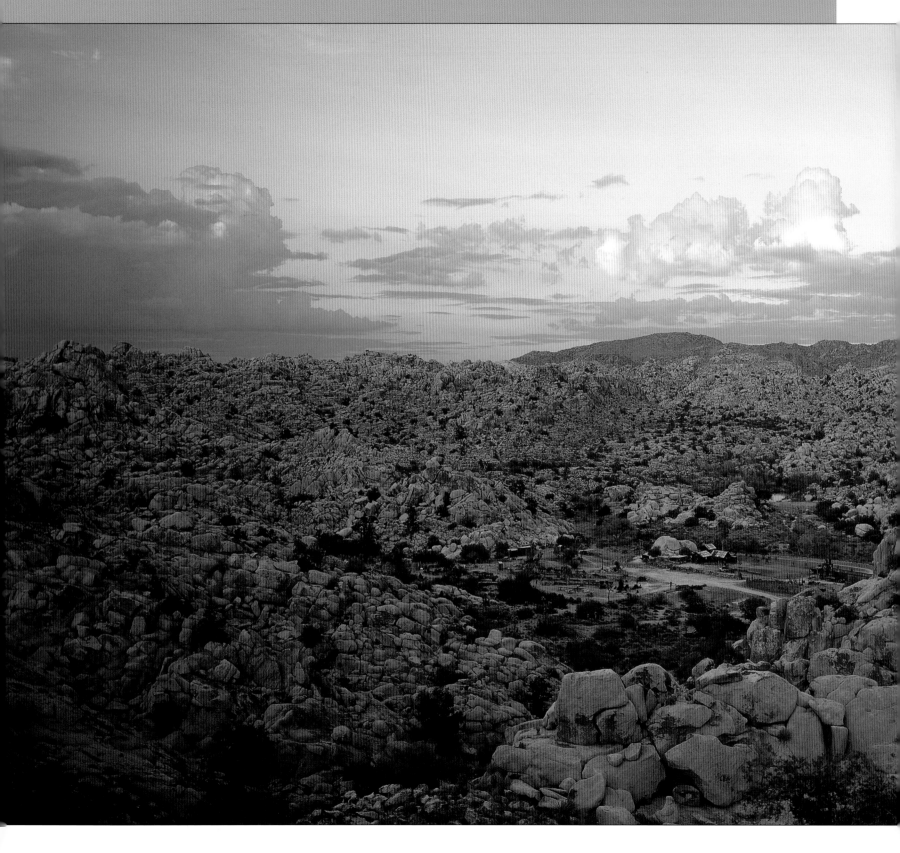

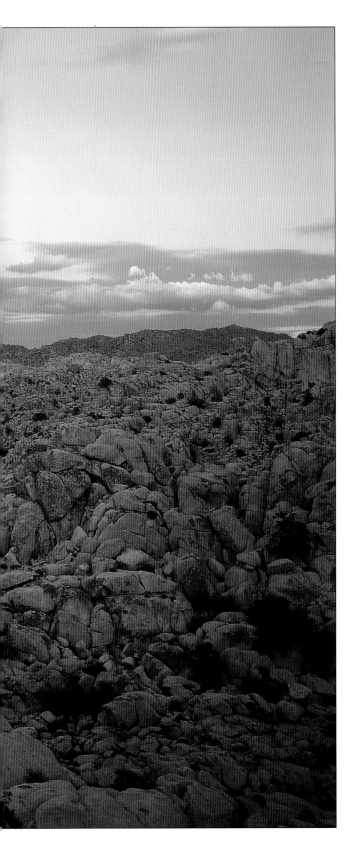

Some of the oldest archaeological sites in Southern California have been found in the Pinto Basin area of the park. They may have been inhabited as early as 8,000 years ago by people of what is now called the Pinto culture. Subsequently, the Serrano occupied the area and lived here into historical times. They were seminomadic, living between this area and the slopes of San Gorgonio Mountain and the Big Bear region. Cahuilla peoples also lived within the park near the current southern borders in the Little San Bernardinos. Later on, the Chemehuevis moved into the region to escape conflicts with the Mojaves near the Colorado River.

In the decades at the end of the 19th century, prospectors were finding gold in Southern California and ranchers were looking for grazing land wherever they could, even in the deserts. So by 1900 there were a few ranches in the current park area, as well as scores of mines and a small mining town named Dale on the northern edge of the Pinto Basin area. The park's most famous resident was Bill Keys, who was a miner and rancher here until his death in 1969. Tours of his still-standing ranch give a fascinating view into the life of a desert settler.

The park has two entrances on the northern Mojave side and one on the southern Sonoran side. There is a visitor center at the main entrance in the town of Twentynine Palms that has information and amenities. The north side is the most accessible and has what most people come to see—namely, the rock formations and Joshua trees. Once inside the park you can drop down into Pinto Basin to get a view of the very different Sonoran Desert. This valley is circled by rugged mountains and epitomizes the "basin and range" topography of the western deserts.

Keys Ranch View

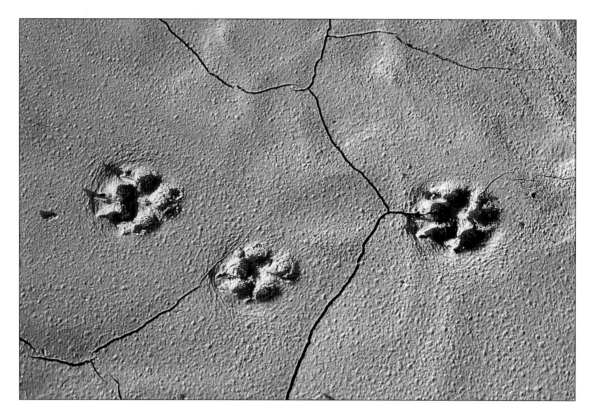

Coyote tracks

Despite its proximity to the heavily populated Los Angeles Basin, this park remained remarkably unknown and tranquil for most of its history. With the increased popularity of rock climbing in the 1980s, and then with its designation as a national park, this natural environment finally caught on as a prime outdoors destination. Despite the occasional crowding, mostly in the springtime, there's no doubt that Minerva Hoyt would have appreciated everyone enjoying her vision of "silence and mystery."

Right: Live oak at Jumbo Rocks

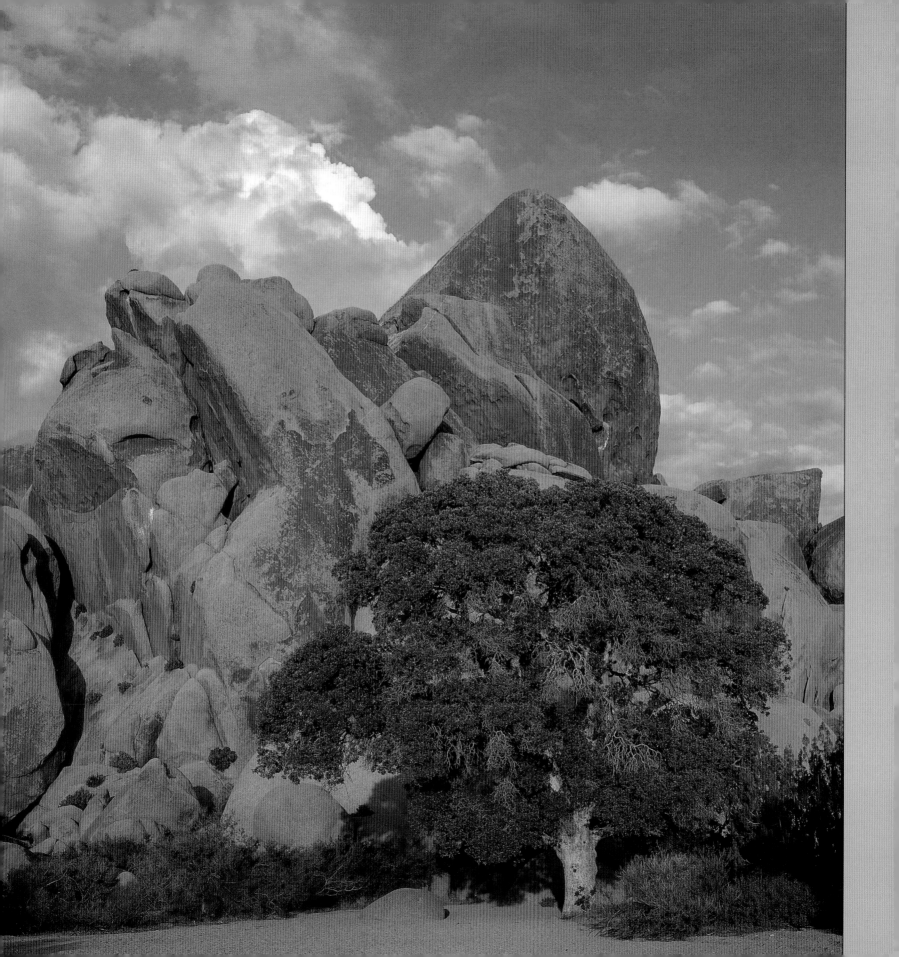

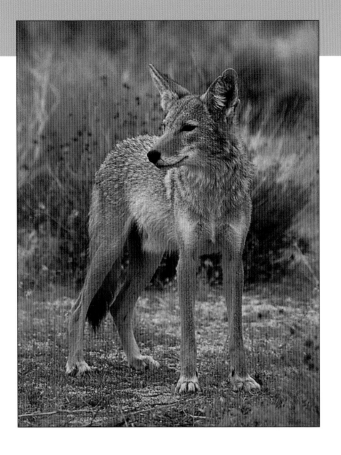

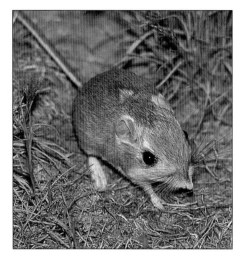

Clockwise from top left: Coyote,
kangaroo rat, jackrabbit, and
bighorn sheep

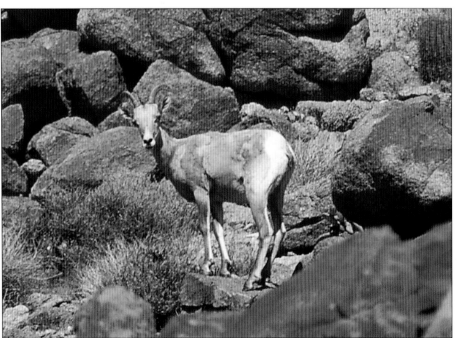

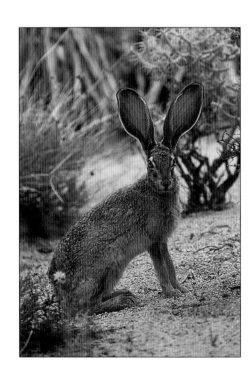

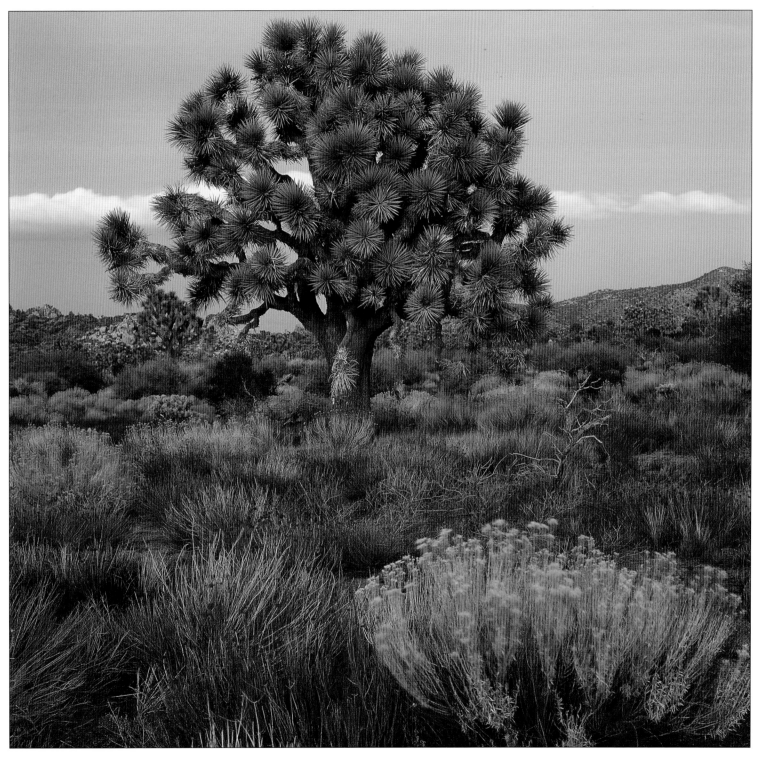

Joshua tree, Covington Flats

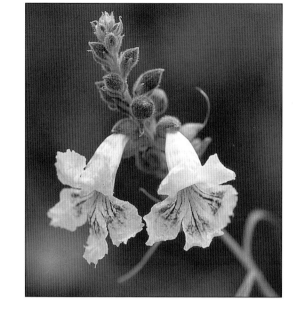

Left: Indian paintbrush;
Right: Desert willow;
Below: Sand blazing star

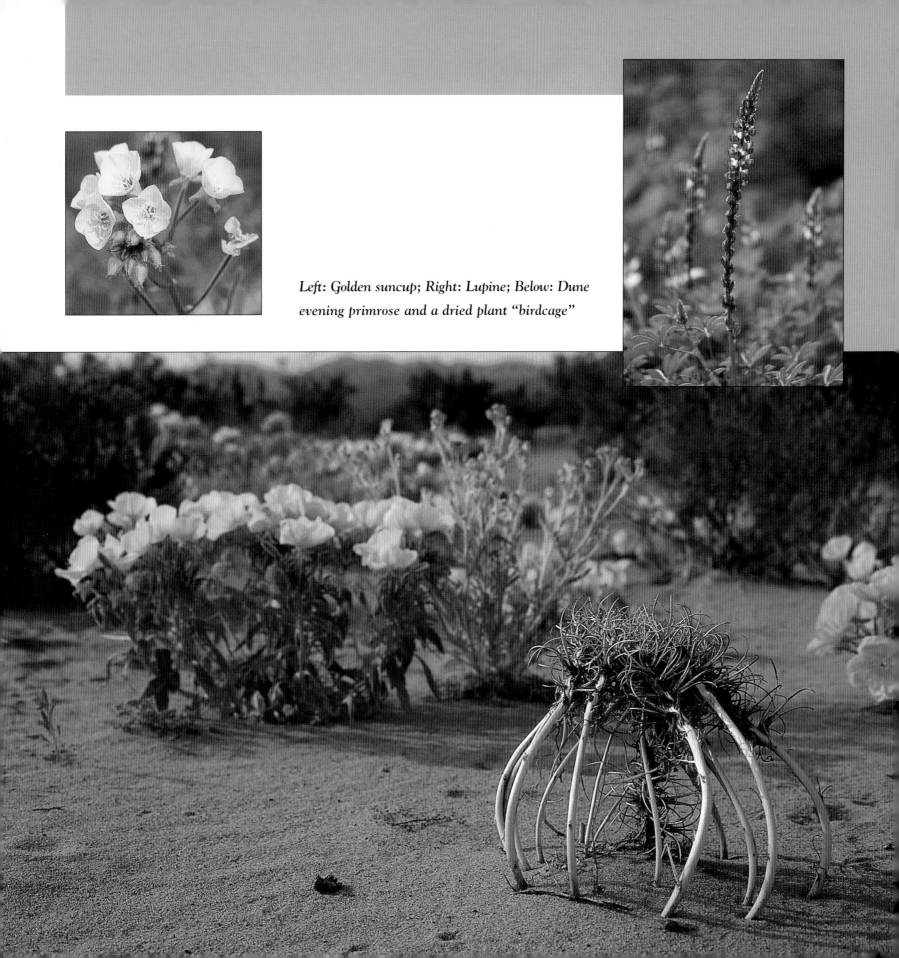

Left: Golden suncup; Right: Lupine; Below: Dune
evening primrose and a dried plant "birdcage"

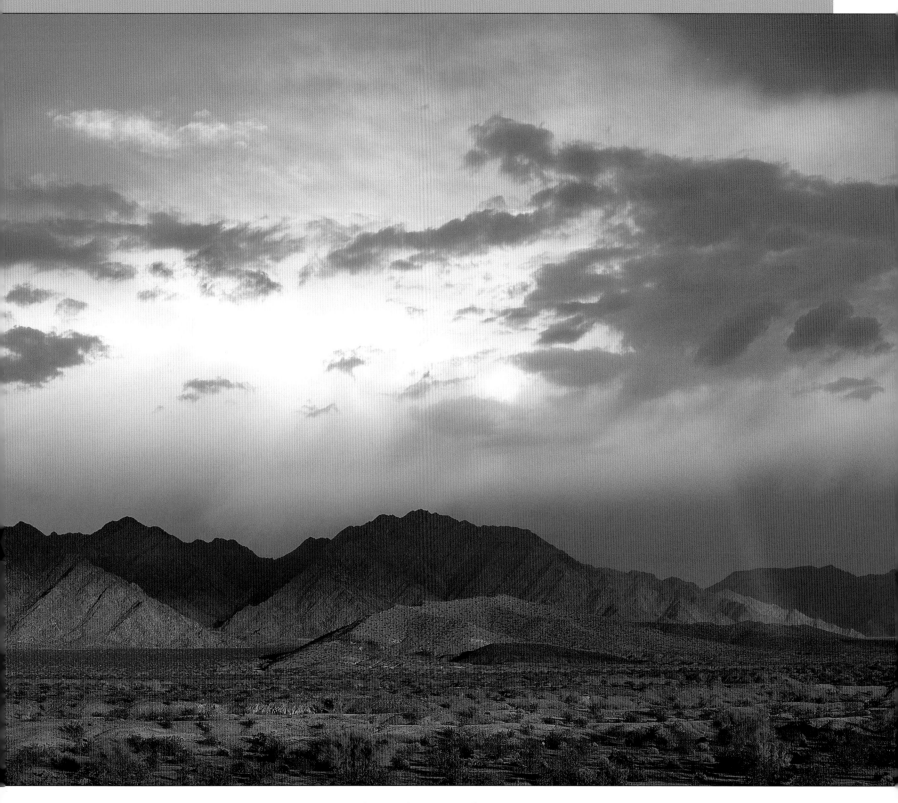

Storm clearing in the Pinto Basin

Malapai Hill

Saddle Rock and Ryan Mountain
Right: Goldenbush, Wonderland of Rocks
Next page: Dune flowers and Sheep Hole Mountains

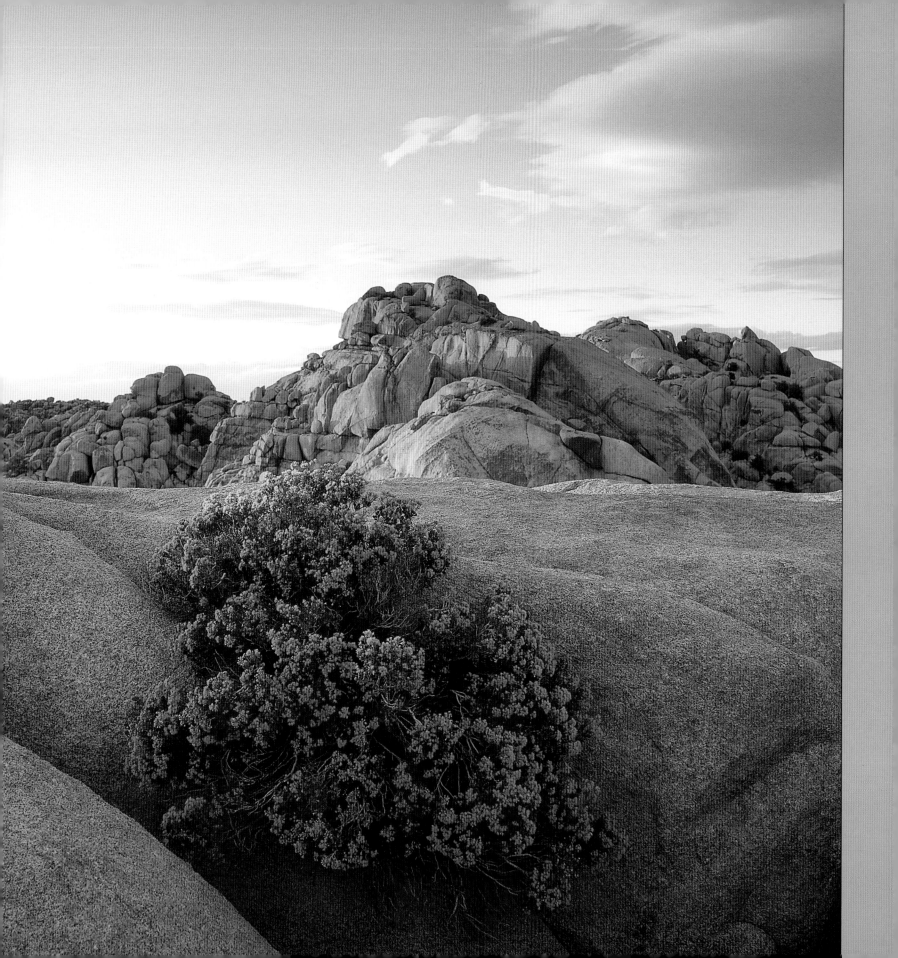

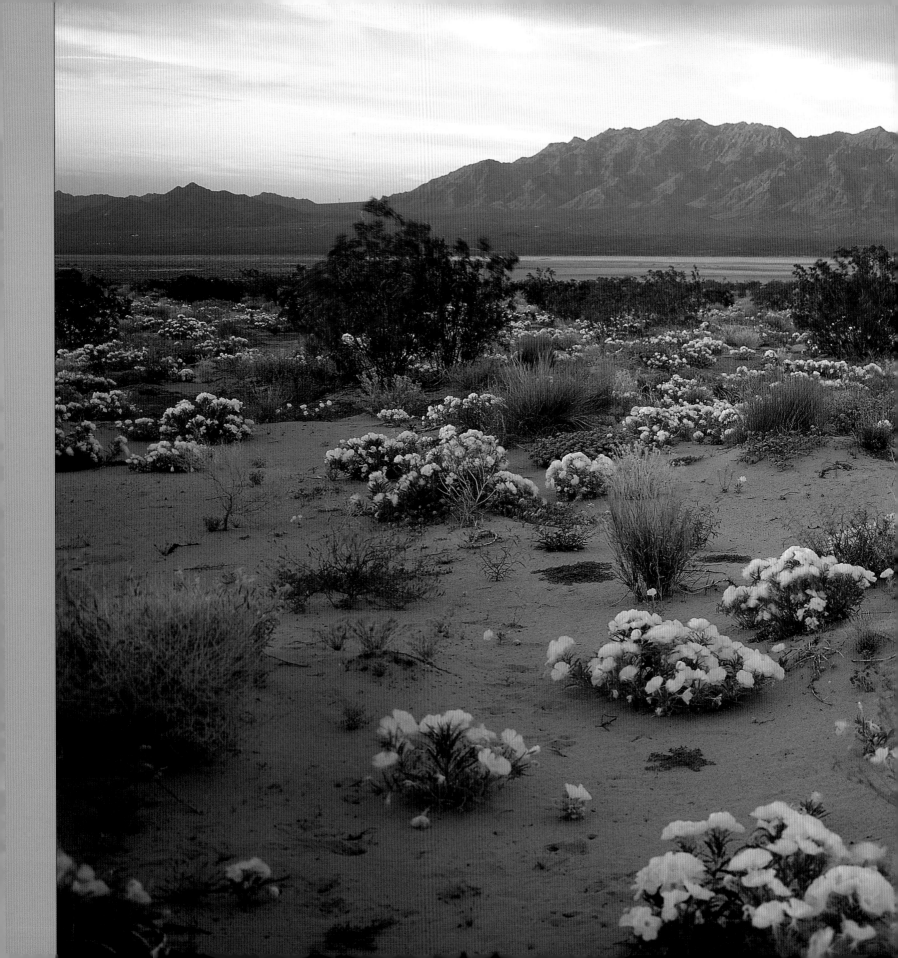

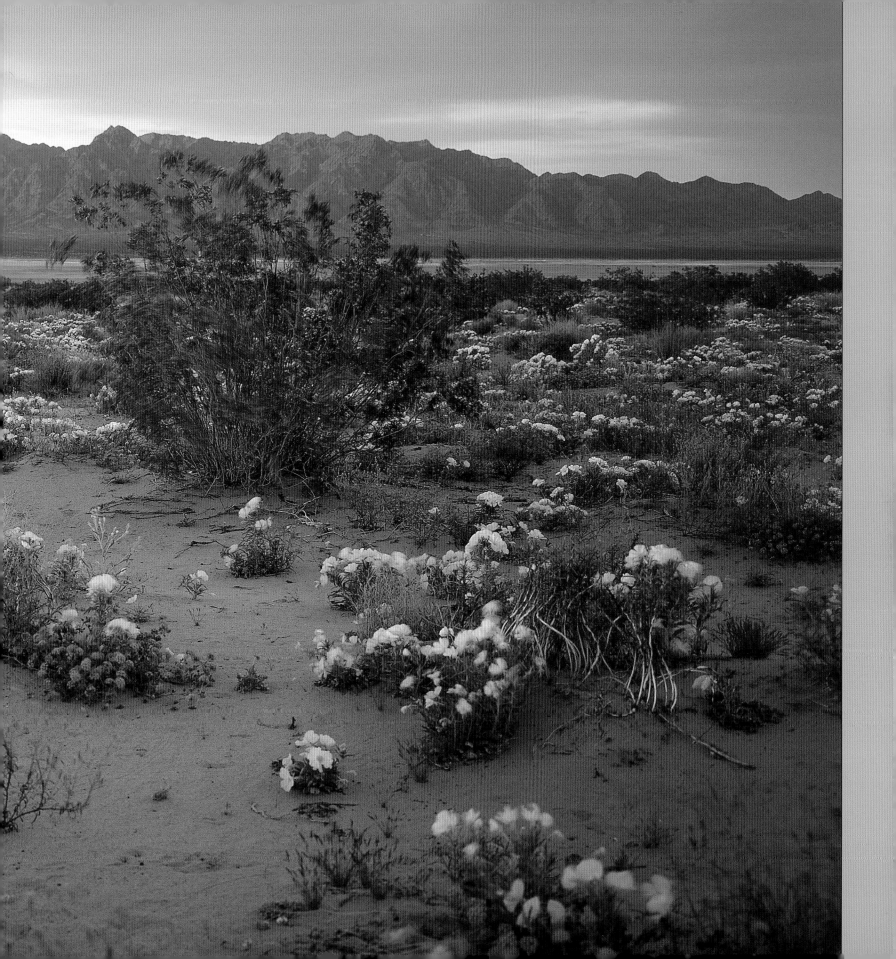

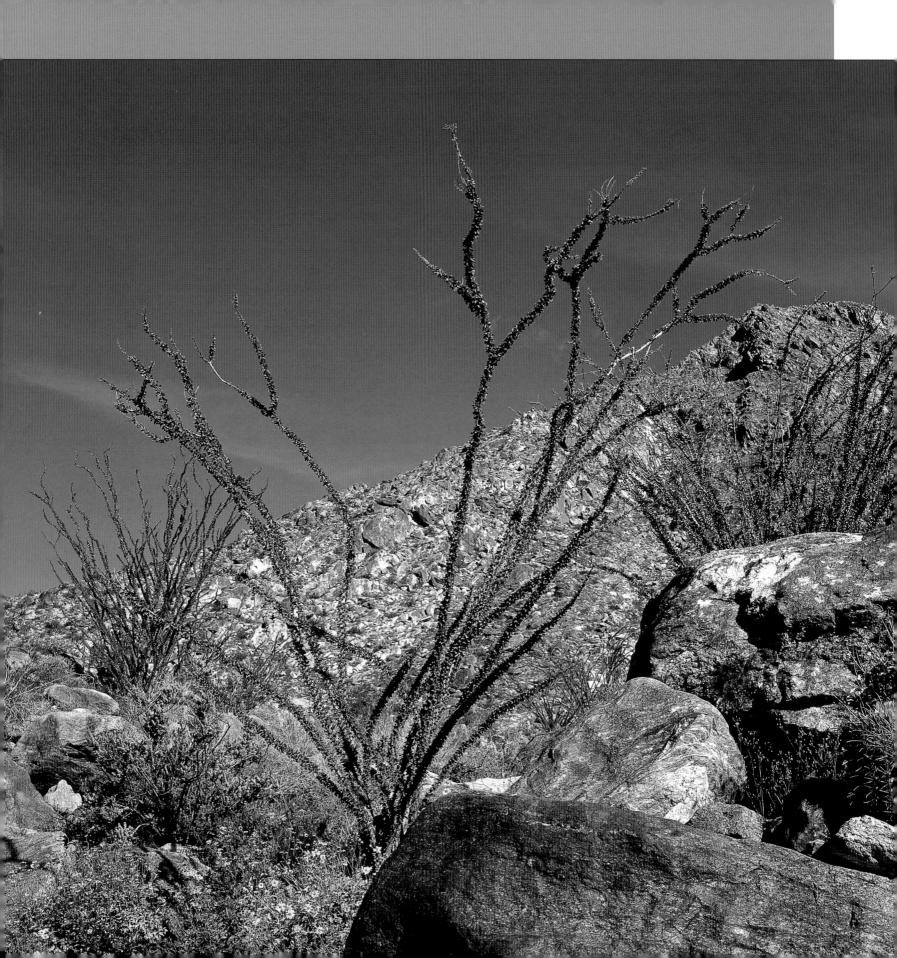

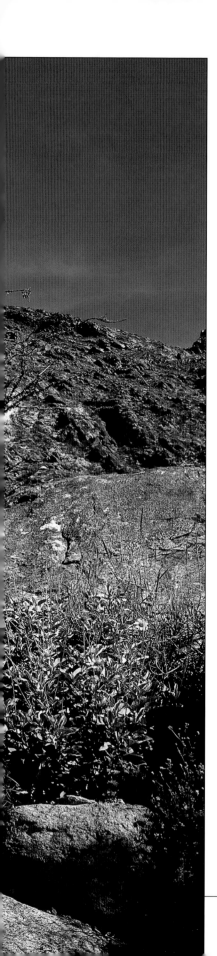

ANZA-BORREGO DESERT STATE PARK

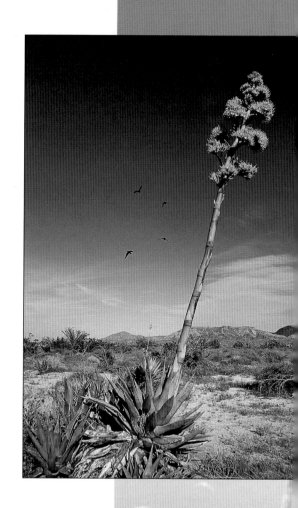

Anza-Borrego Desert State Park contains some of the most fascinating desert scenery in the nation. With more than 600,000 acres, it is the largest state park in the lower 48 states, sprawling from almost below sea level to over 8,000 feet. The diversity of terrain covers three climactic zones including desert, chaparral, and highland forest. It has marshes, numerous palm oases, and the longest perennial stream in San Diego County. The park continues the belt of protected land along the Peninsular Mountains from the southern end of the Santa Rosa and San Jacinto Mountains National Monument

Borrego Palm Canyon

almost to the Mexican border. The park's name represents its link to history and the environment: Juan Bautista de Anza was the Spanish explorer who came through this area seeking a route to Monterey, and borrego is the Spanish name for the bighorn sheep that live on these hillsides.

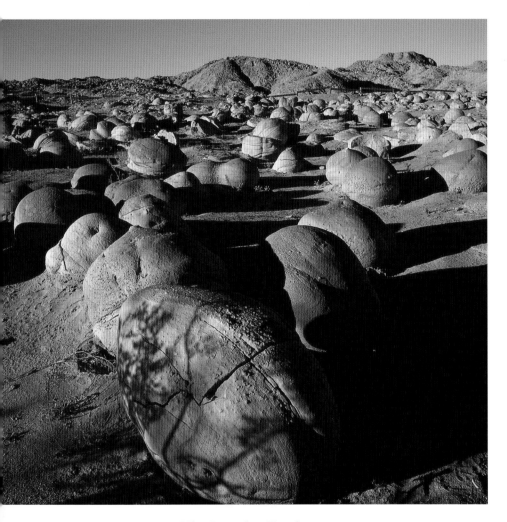

The Pumpkin Patch

Anza-Borrego must be a geologist's dream—or perhaps nightmare—to interpret, since there have been so many forces that have worked to create this landscape. The area is a part of the northward-moving slab that was once attached to Mexico. On the journey north it was subjected to experiences above and below seas, to periods below large freshwater lakes, to wrenching by tectonic forces and reshaping by volcanic eruptions, and then to weathering by eons of changing climates. The landscape created by these forces has features such as rugged mountains, eroded badlands, twisted layers of rock, volcanic hills, and fossil shell beds and coral reefs thousands of feet above sea level.

Evidence indicates that people arrived here about 9,000 years ago, and possibly even earlier. The Kumeyaay and the Cahuilla in this area survived into historical times, and even though they came from different language families they seem to have coexisted peacefully. The Spanish entered the region in the 1770s, most significantly with the Anza expeditions that established the trails over the mountains in what is now this state park. Spanish migrants, and others later on, periodically used these routes to reach coastal and Northern California. However, non-Indians did not start settling here until the 1870s when

(continued on p. 82)

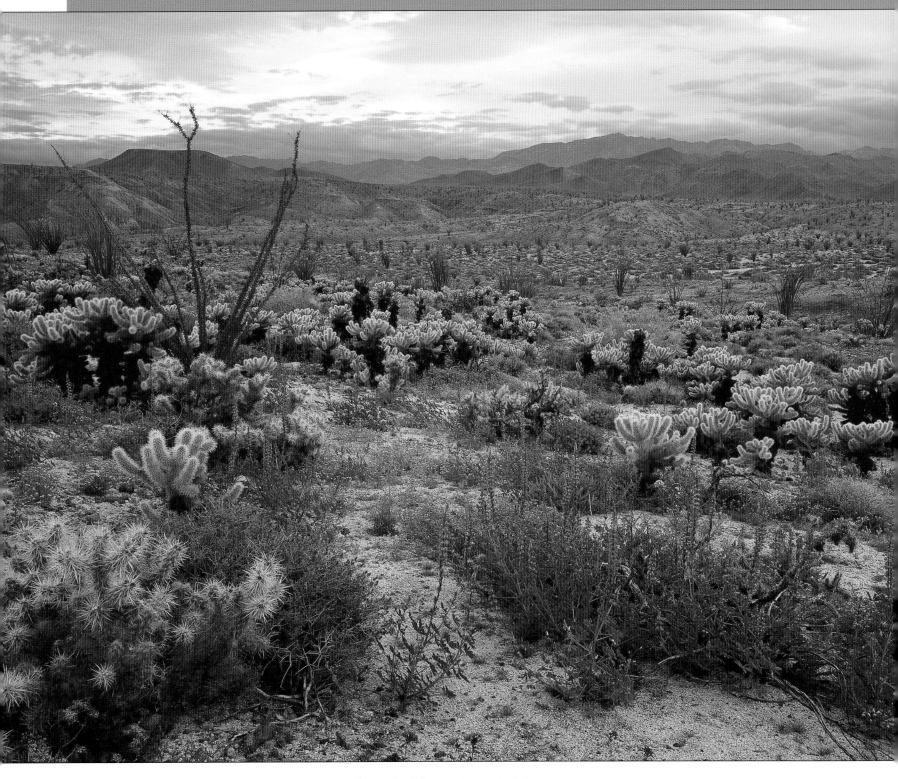

Jacumba Mountains and plain

Next page: View from Fonts Point

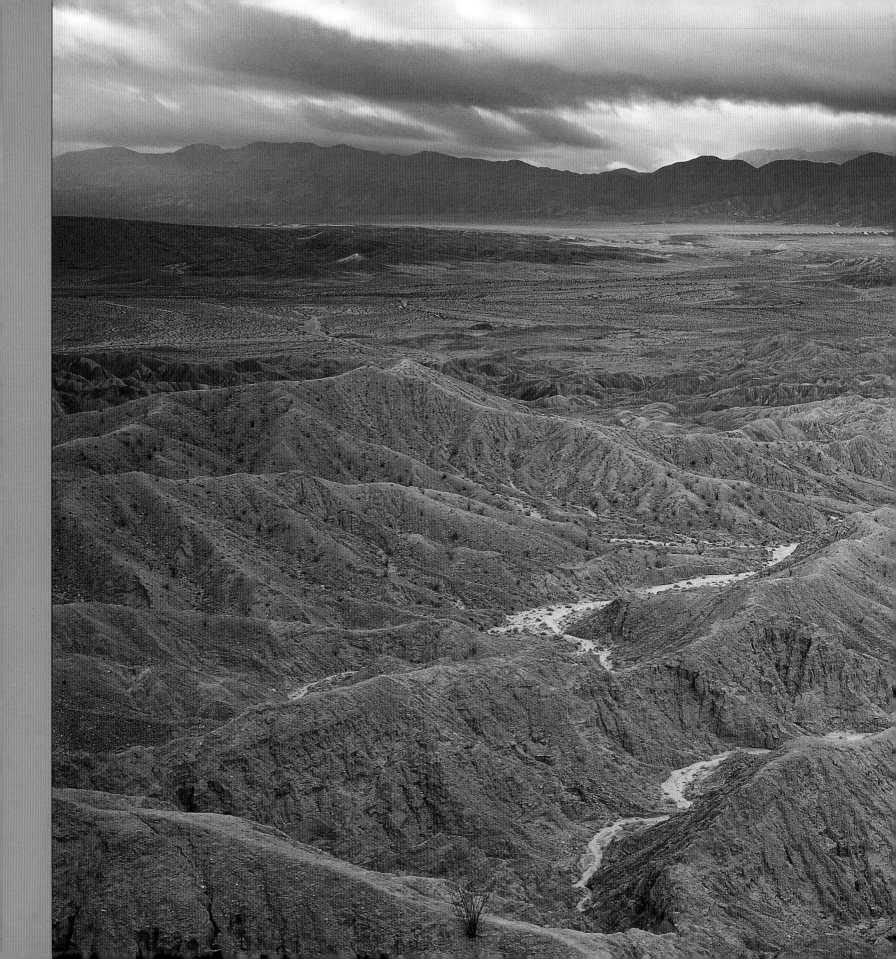

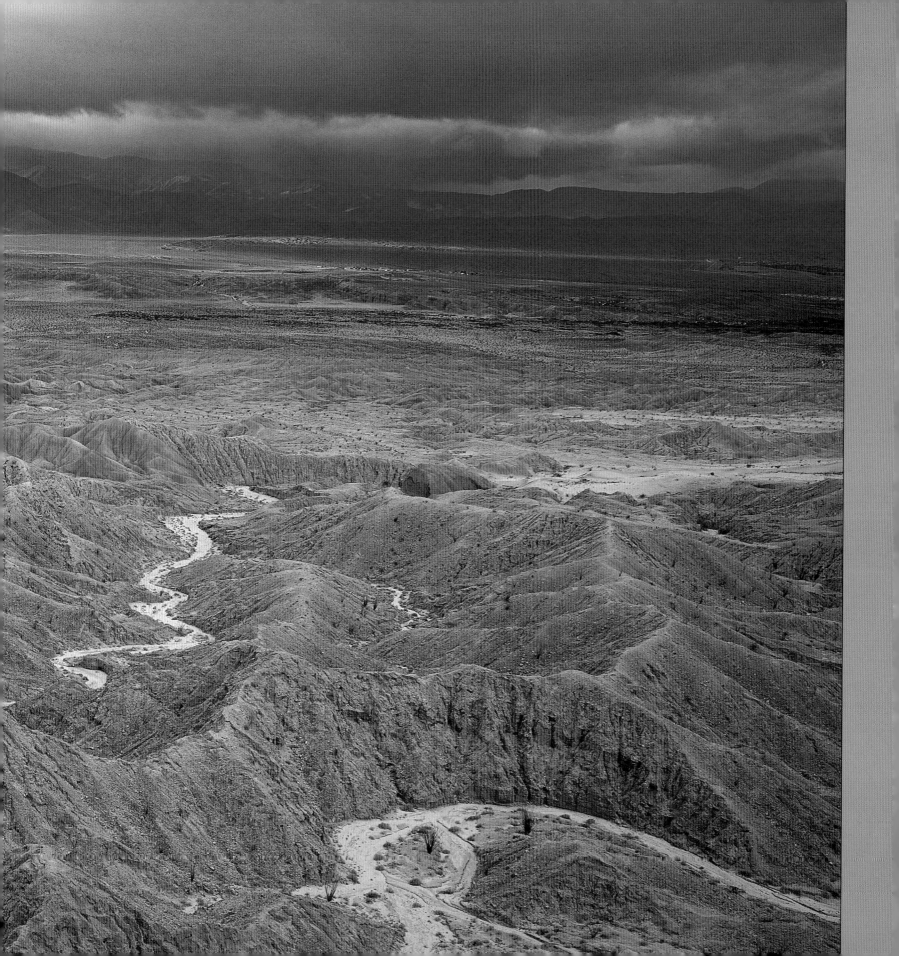

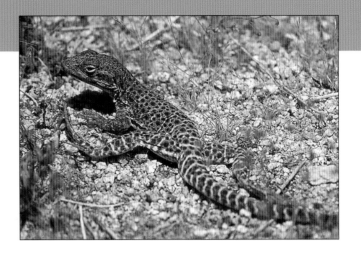

Left: Chuckwalla;

Right: Leopard lizard;

Below: Speckled rattlesnake

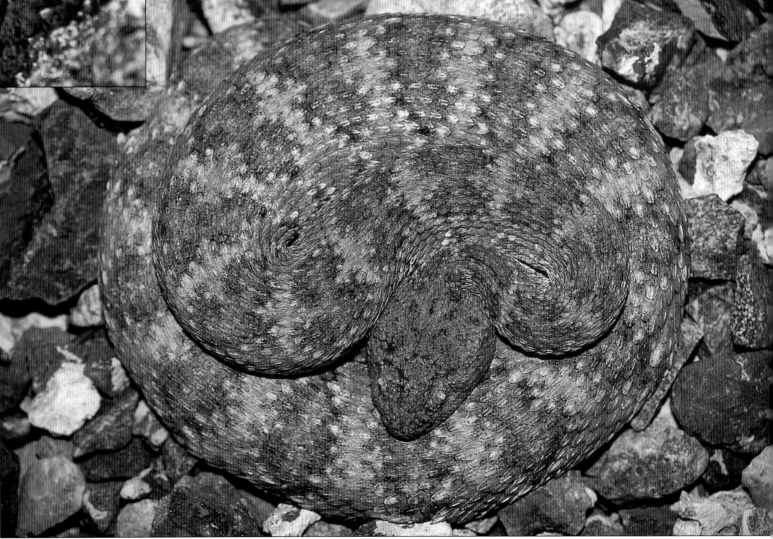

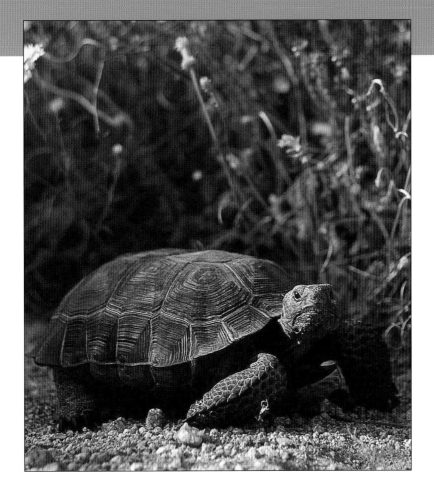

Clockwise from top left:
Desert tortoise, collared lizard,
and horned lizard

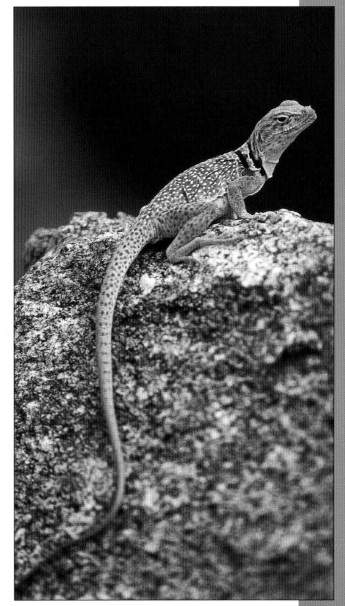

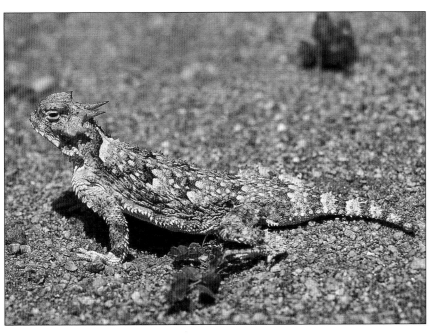

ranchers discovered the Borrego Valley. With a successful well dug in 1926, irrigation farming became possible and the community prospered.

Work on creating a park here began in 1928. The state started acquiring land for the park in 1933, but it took many decades to bring together all the pieces to make the park we see today. This park has 110 miles of hiking trails and is laced with 500 miles of dirt roads. A unique aspect of this park is that camping is allowed almost anywhere you want alongside a road, so access to most areas is relatively easy with a four-wheel-drive vehicle—which is fortunate because there's a great deal to see.

Anza-Borrego is within the Sonoran Desert, overall the hottest of the American deserts, which runs into Arizona and Mexico. It is protected by the Peninsular Mountains from the effects of coastal moisture. In this hot, dry region, a multitude of plant varieties have been allowed to express their unique spirit. And express this they have, as the plants of the Sonoran Desert are rivaled only by those of South Africa in the development of unusual—and occasionally bizarre—forms.

Entering the park from the Coachella Valley on CA 22 takes you up a long, low grade over the layers of sedimentary formations. If you have four-wheel drive, numerous dirt roads cut down through the layers and invite you to explore, but if you're not careful it is easy to become lost in a maze of badlands. Fortunately, the circumference is ringed

17 Palms Oasis

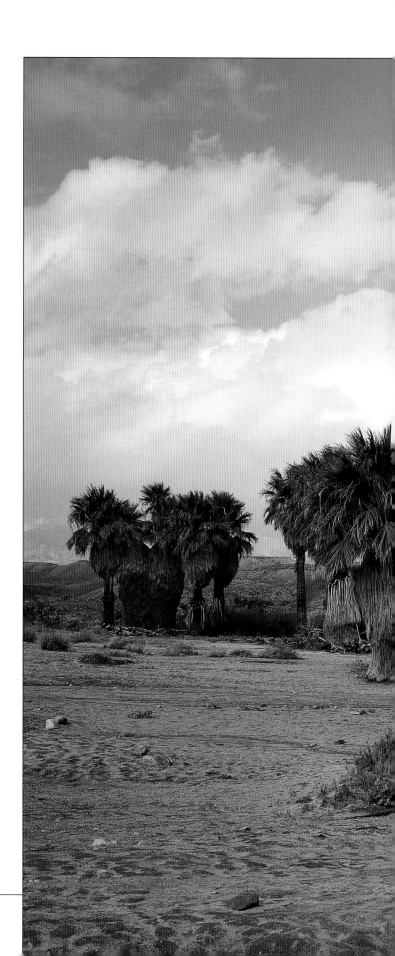

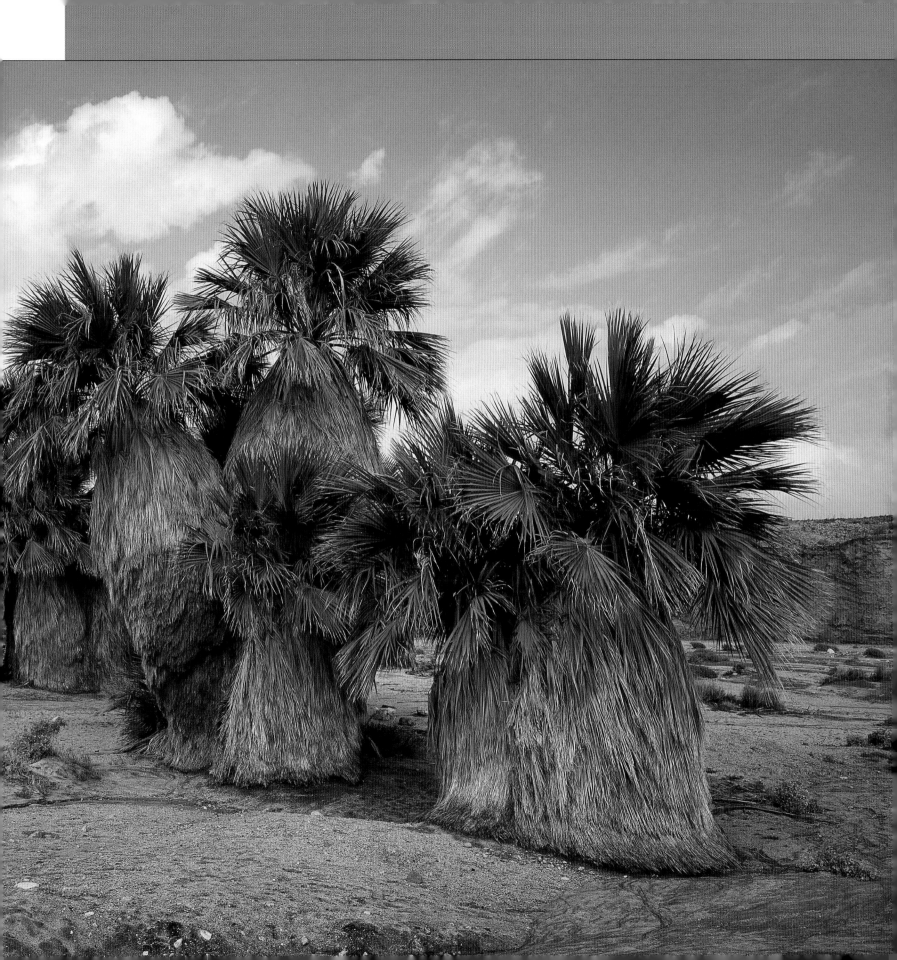

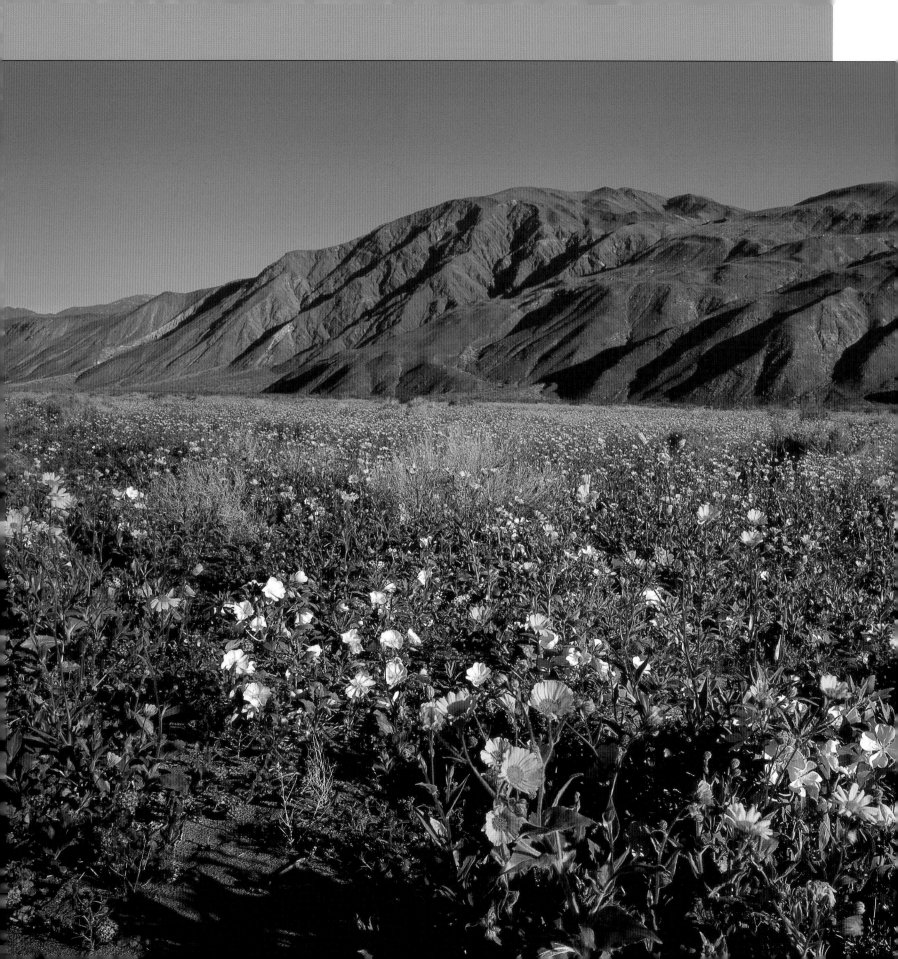

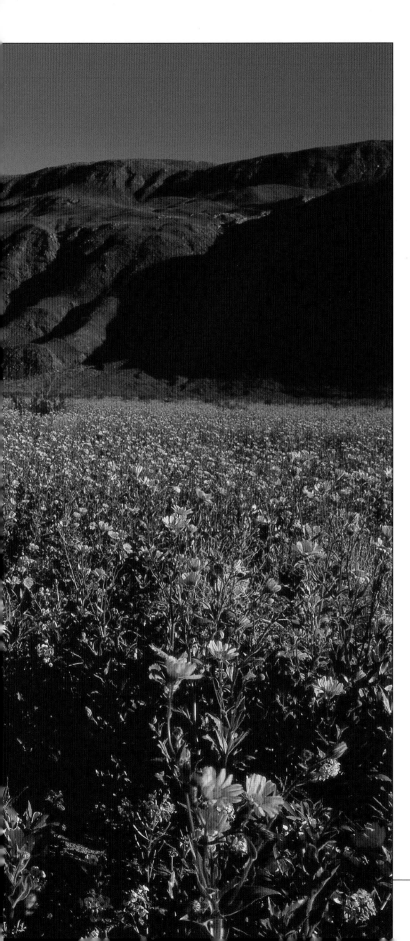

by paved roads, so with persistence you will emerge somewhere—but not without a new respect for the desert and geological history. If you make it back on to CA 22 and take a right before you come to the town of Borrego Springs, you may descend into a broad valley to encounter a dry lake—unless it has rained recently, in which case you may become trapped in mud before you realize the ground is a bit soft. Backing out to the paved road, you can continue on to town. Or, after a couple of right turns, you will come to another dirt road—but this one is well cobbled, and has an inviting creek running alongside. Venturing forth, you parallel the creek through a beautiful landscape of ocotillos, agaves, and cacti to enter into a swamp. Pressing on through the riparian base of the canyon you encounter a road challenging even for a jeep, and looking up you can see the snowcapped peak of Mount Toro. If you come out and make it to dinner in Borrego Springs, you may hear tales that lead you to believe that you saw one of the less interesting areas of the park. If the desert is a lab for geology, Anza-Borrego is a final exam. Even staying on paved roads and taking the occasional hike as far as you are able will show you remarkable sights, and raise perplexing questions about the formation of this region.

Spring blooms along Henderson Canyon Road

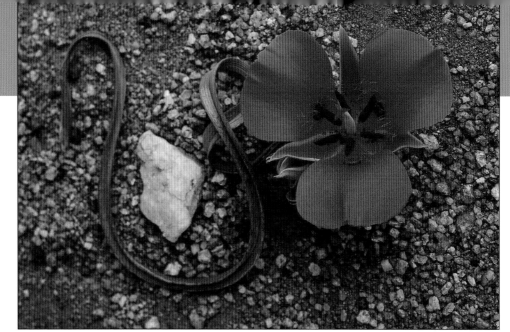

Clockwise from top left:
Live-forever, Mariposa lily,
scalloped phacelia, and
coyote melon

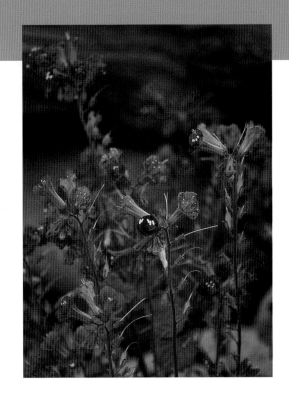

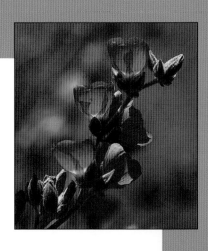

Clockwise from top left: Canterbury bells, globemallow, desert trumpets, and sand blazing star

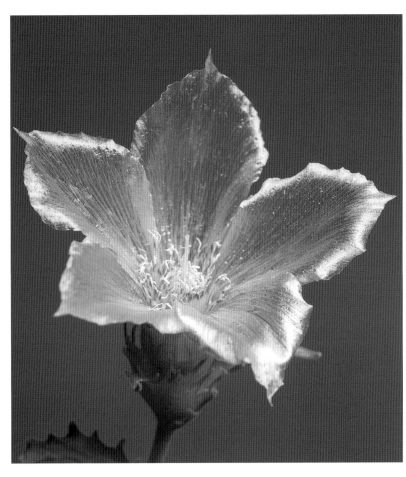

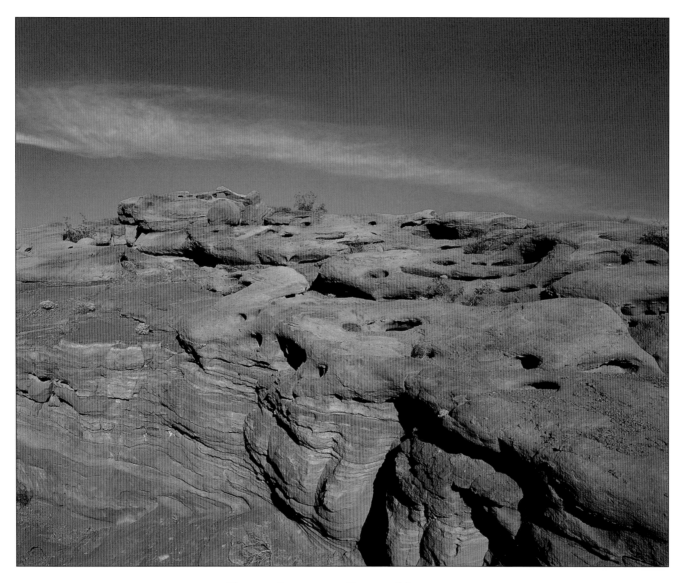

Erosion features on Borrego Mountain

Right: Borrego Palm Canyon
Next page: Sweeny Pass

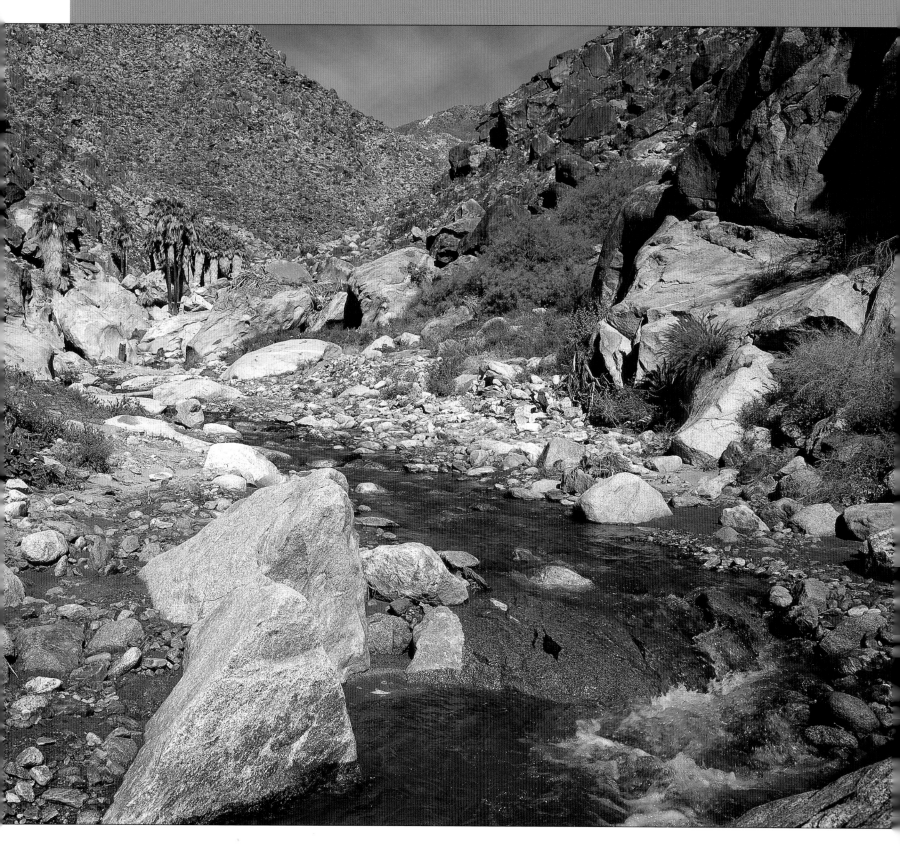

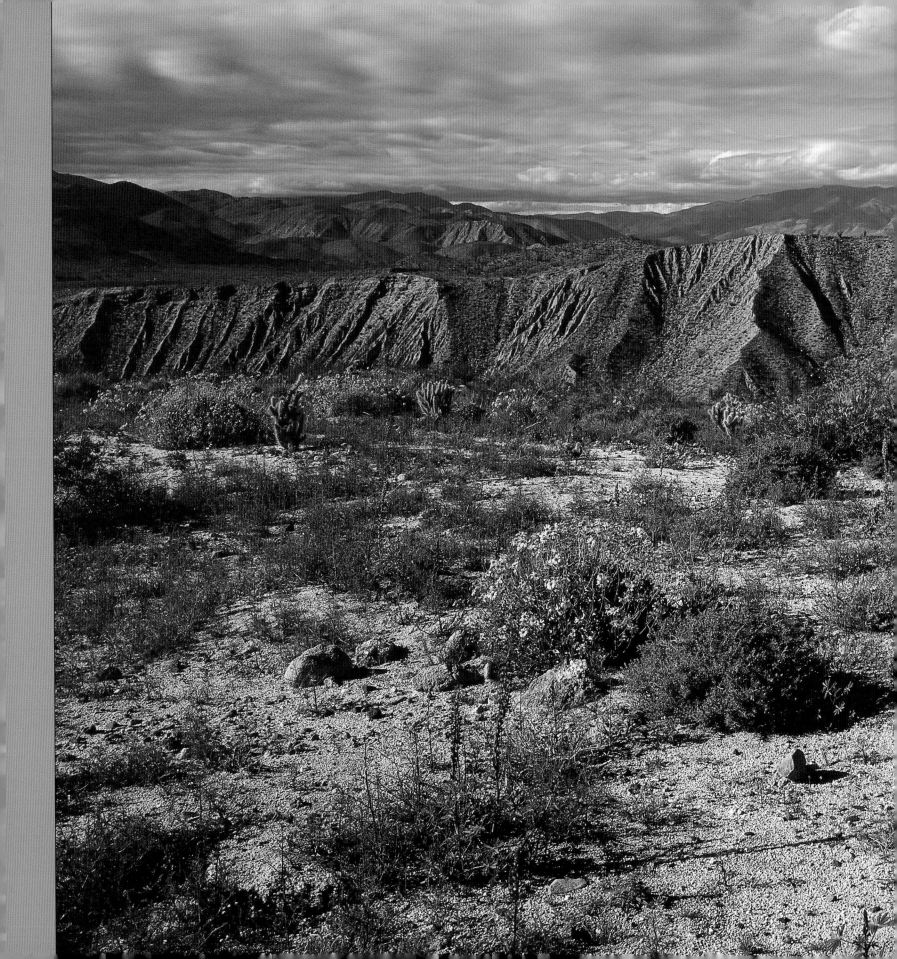

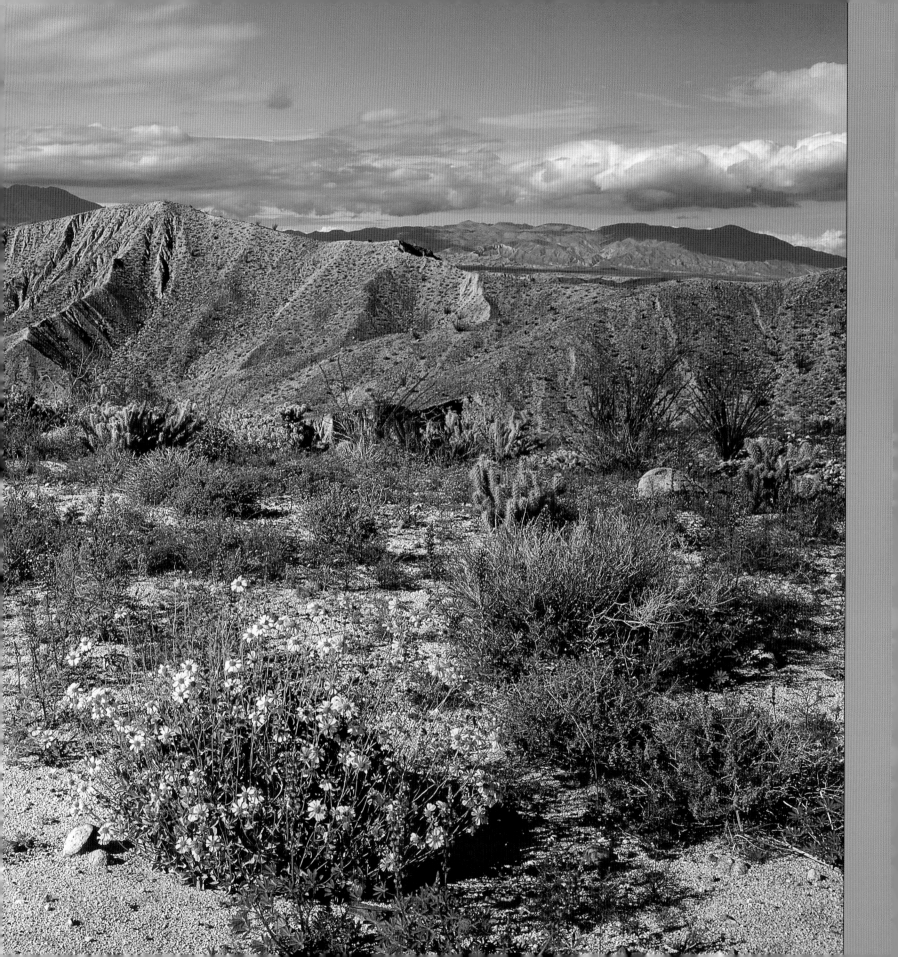

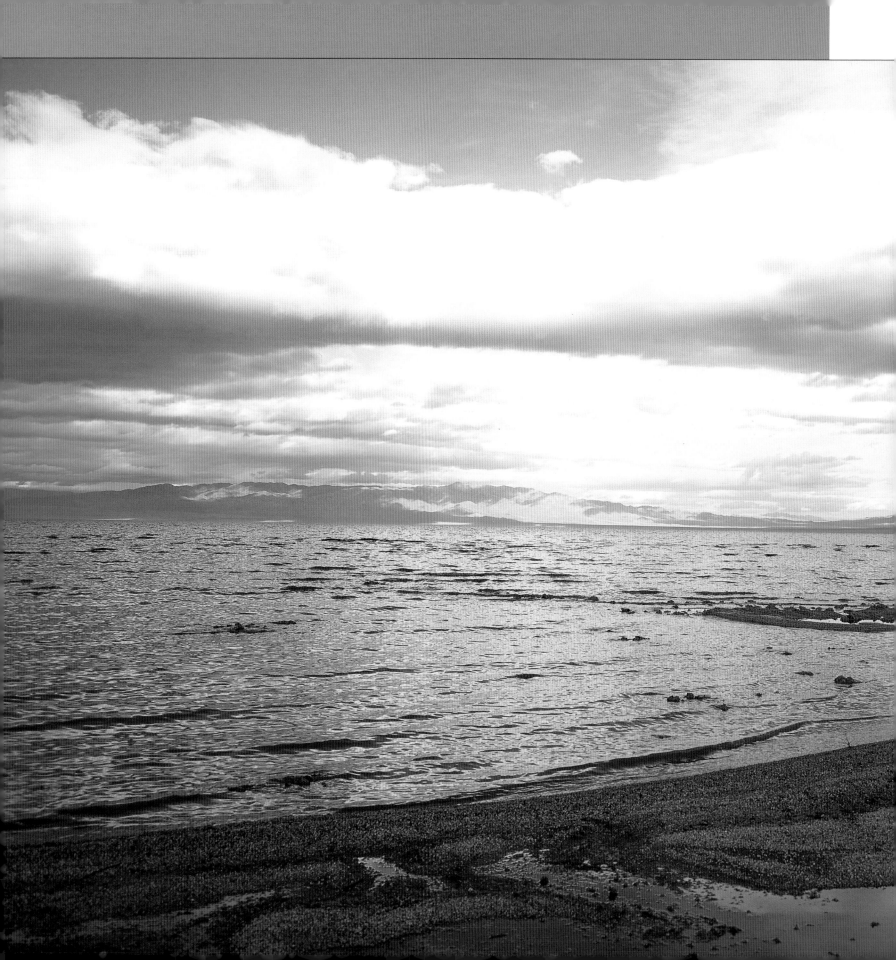

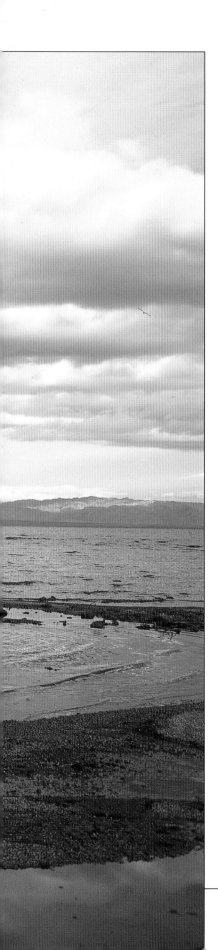

Farther Out

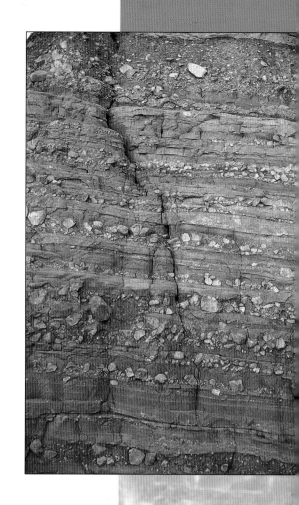

O nce a taste for the desert is acquired, curiosity will draw you further into the backcountry. The mountain range in the distance may beckon, or it simply may be a highway exit in the middle of nowhere that fires the imagination and causes you to pull off the known road and venture out. What is fascinating about this region is that there is plenty of land to explore.

A good place to start is the Salton Sea. It is the biggest lake in California, and in times past was as much as six times larger. Millions of years ago when the Salton Trough was submerged under the Gulf of California, salt accumulated in the sediments deposited at the bottom of the sea. Later on, the Colorado River created a delta that dammed off a portion of the bay, eventually allowing the sealed-off sea to evaporate. At various times the river changed course, allowing its entire flow to fill up the basin. In the last 2,000 years alone, Lake Cahuilla (as the ancient lake is called) has been filled three times to become a large lake that persisted for hundreds of years, and many other times as a small lake. There are various

Salton Sea shoreline

places in the valley where old shorelines can be seen on the hillsides. Because of the salt in the soils here, the lakes that have formed have been salty; the salinity of the current sea is greater than that of the ocean.

The Salton Sea we see today was created by accident in 1905 when a company digging irrigation canals to siphon off some of the Colorado River into the valley weakened a levee. The waters broke through, and for two years the entire river drained into the Salton Trough, 271 feet below sea level. It would have evaporated away years ago except that the water level is now maintained by irrigation runoff. Therefore, the sea has created marshlands along some of its shoreline and has become an important stop on the Pacific Flyway for migrating birds. The sea became a fashionable fishing and boating resort area from the 1940s to the 1960s, but subsequently lost popularity—although it still draws numbers of people here for fishing and bird-watching. There are a few designated wildlife-viewing areas along the shores that provide good outposts to observe some of the more than 400 species of birds known to visit the sea. In recent years there has been concern about increasing salinity levels and contamination of the lake, as well as occasional die-offs of fish and bird life due to algal blooms and unknown diseases. Programs are being implemented to reduce the salinity and restore the health of the Salton Sea. A trip around this lake offers an intriguing view of the changing tastes for recreation over the last 50 years. Many motels and marinas spotting the shoreline have fallen derelict as their use dwindled and eventually ceased altogether.

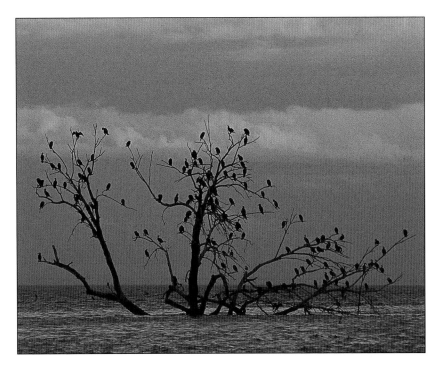

Birds roosting at the Salton Sea

North of the Salton Sea is a line of weathered hills, which seem to be completely barren. These are the Mecca Hills, a badlands area containing a designated wilderness area of more than 41,000 acres. Here you are standing on the San Andreas Fault, and are seeing the results of uplift

at the most local level. Some of the rocks and sediments in this site are more than 600 million years old. This is a fascinating area to get a close-up view of the geological forces shaping the region. A series of trails wind through the canyons here; some use ladders to ascend difficult sections, while others bring you to grottoes or a hidden oasis. Painted Canyon is in the center of this area, and a variety of mineral deposits have colored the hills shades of rose, green, lavender, red, and purple. Sunset or soft lighting brings out the colors in a remarkable display of earth tones. Most of the time the hills here seem lifeless, but a bit of rain will perk up seemingly dead bushes and bring out rare flowers.

All of the places discussed so far have been accessible by paved or well-maintained dirt roads. At some point in your desert explorations, you will realize that you require a four-wheel-drive vehicle just to get access. The closest area to the Coachella Valley where this is necessary is the

(continued on p. 98)

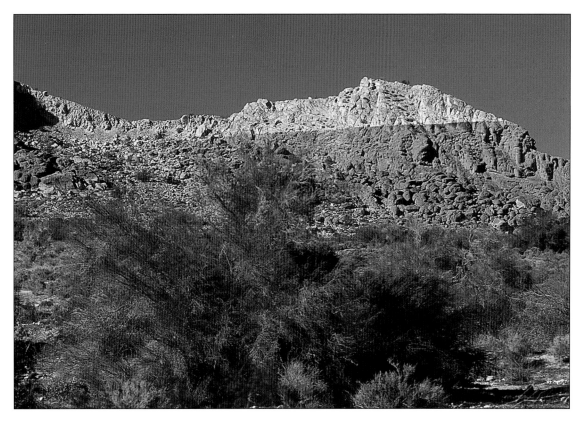

Ancient shoreline of Lake Cahuilla
Next page: Mecca Hills

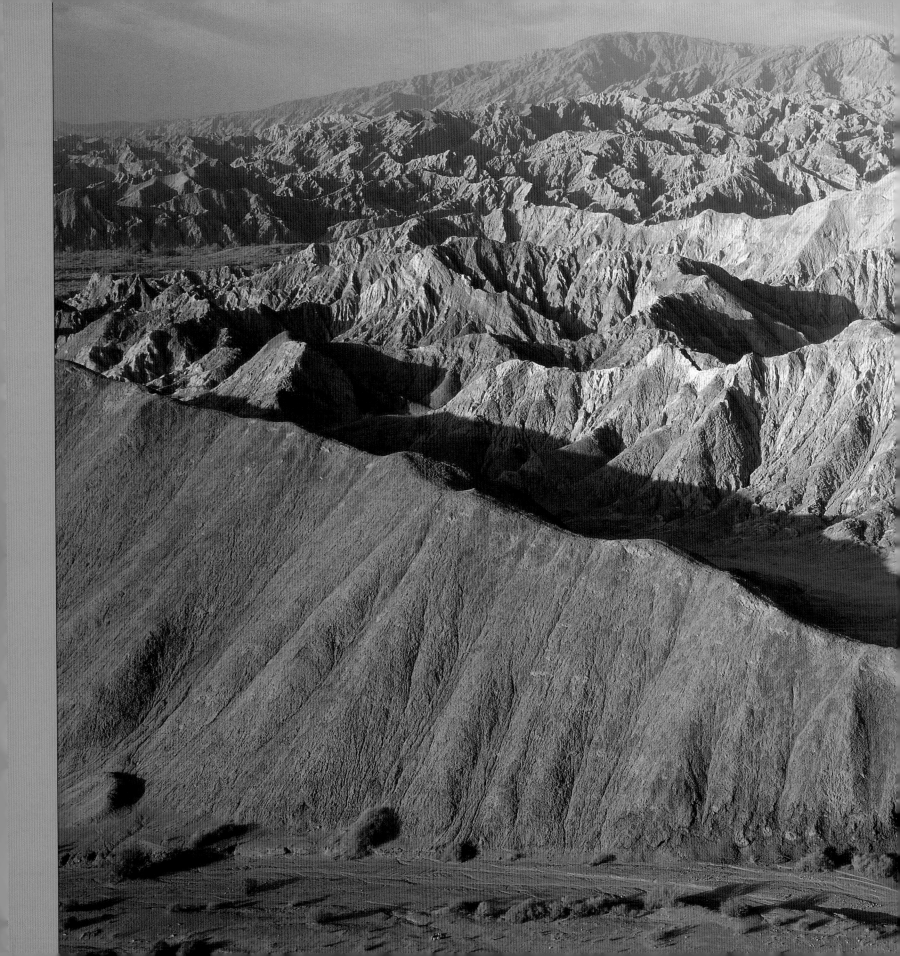

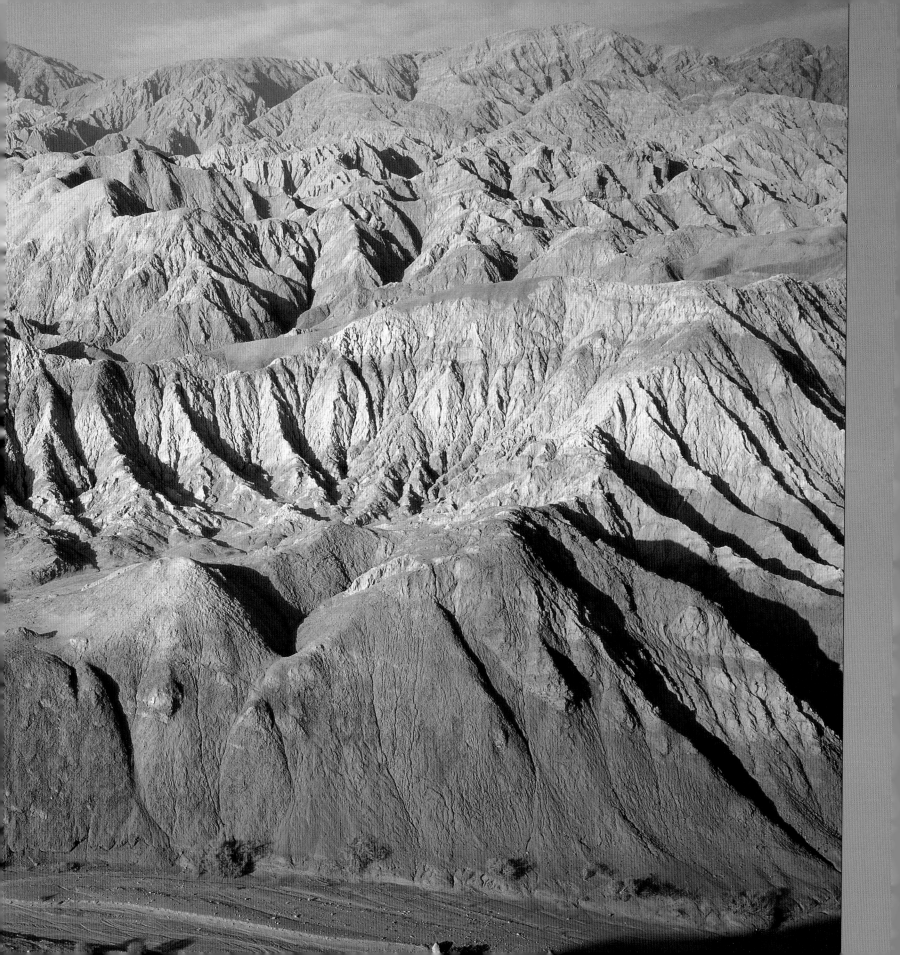

Orocopia Mountains Wilderness. These mountains, which are east of the Mecca Hills, encompass almost 46,000 acres of designated wilderness area—and hide some dramatic red sandstone canyons. In addition to the usual assortment of desert animals, bighorn sheep and mule deer can be seen in this area. Those with a careful eye may spot fossils of prehistoric animals embedded in the canyon walls. Southeast of Orocopia are the Chocolate Mountains, named for their various shades of brown. This looks like it would be a beautiful area to explore. However, it is a military gunnery range, which is closed to the public, so we must be content with appreciating it from a healthy distance.

The main access to this area is on an old road called the Bradshaw Trail. William Bradshaw created this route in 1863 as a shortcut from San Bernardino to the newly discovered goldfields on the Colorado River at La Paz, Arizona. Continuing east on this

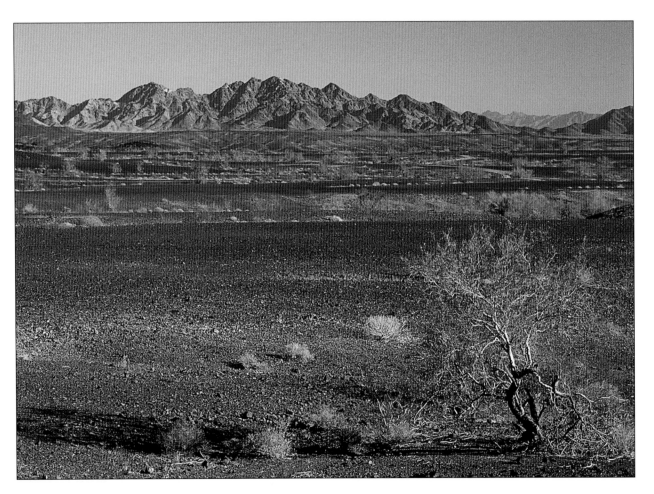

"Desert pavement" in the Chuckwalla Bench

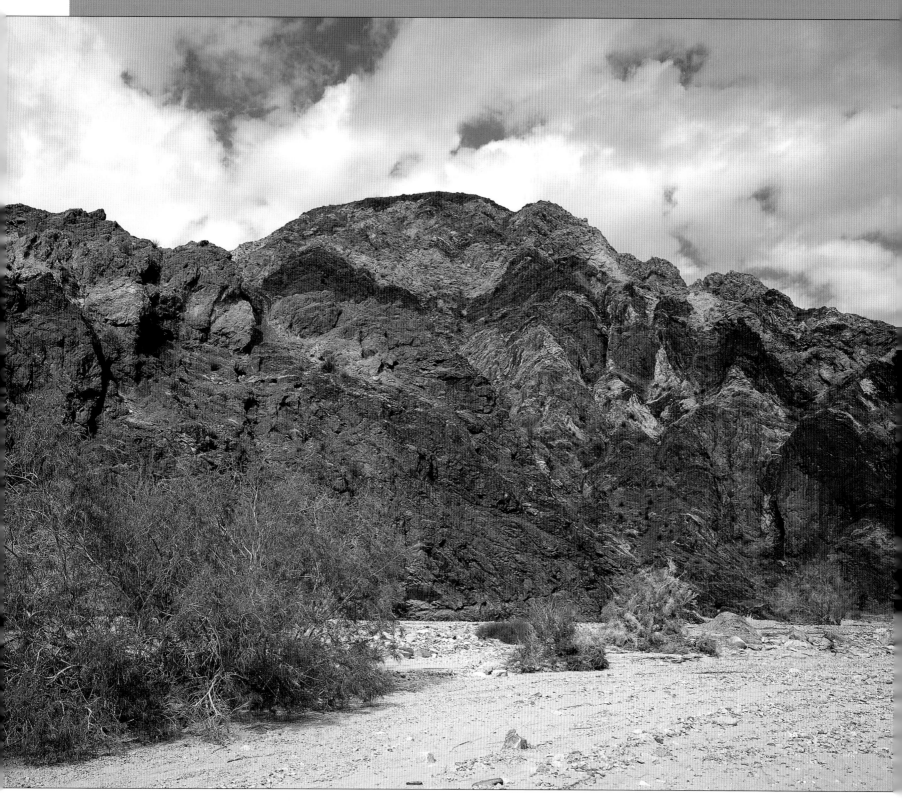

Painted Canyon

road takes you to the Chuckwalla Mountains Wilderness, another region with starkly beautiful desert scenery. There are vast areas of "desert pavement" here, where the stones on the surface of the ground are windblown and fit together so tightly that nothing grows between them.

For those who think a desert must have large sand dunes, the Algodones Dunes east of the Imperial Valley will satisfy any such need. Covering more than 1,000 square miles, this is one of the largest areas of sand dune habitat in the country. However, the government has allocated most of the area for off-highway vehicle use—only the northern fifth has been kept as wilderness. These sands probably came from the lakebed of ancient Lake Cahuilla to the west. And if they look familiar, this is the favored location for filming almost any scene requiring sand dunes.

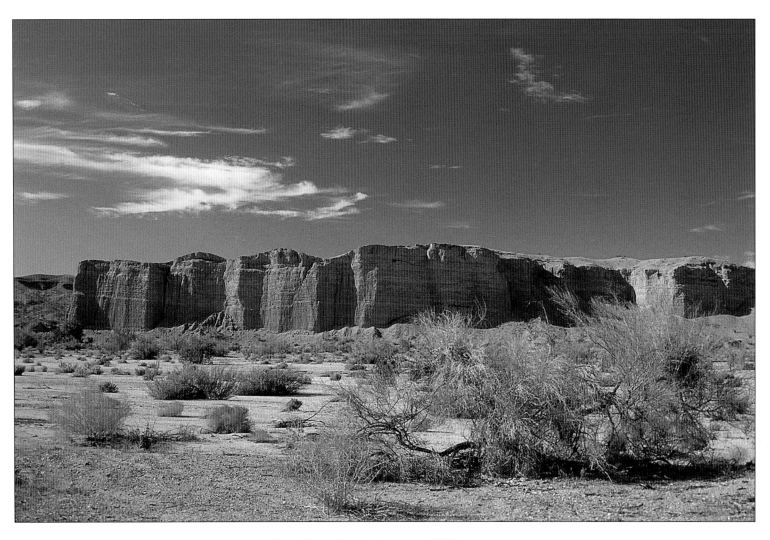

Bradshaw Trail, Orocopia Wilderness

When the desert becomes too hot or intense, this region has an immediate escape right next to it. The San Jacinto Mountains and Santa Rosa Mountains lining one side of the Coachella Valley have numerous peaks over 8,000 feet, all the way up to the top of San Jacinto at 10,804 feet. You can drive through the Santa Rosa and San Jacinto Mountains National Monument up to alpine valleys at 6,000 feet filled with tall sugar pines, or up to Lake Hemet, an alpine lake stocked with trout. The temperatures here can be 30–40 degrees cooler than on the desert floor. There are drive-in campgrounds from which you can hike into Mount San Jacinto State Park or other wilderness areas on the mountains. If you want a bit more comfort while in the area, the town of Idyllwild features numerous accommodations, restaurants, and shops of all kinds. Idyllwild is one of those hidden communities with a thriving creative scene that sponsors many events that attract people from throughout Southern California.

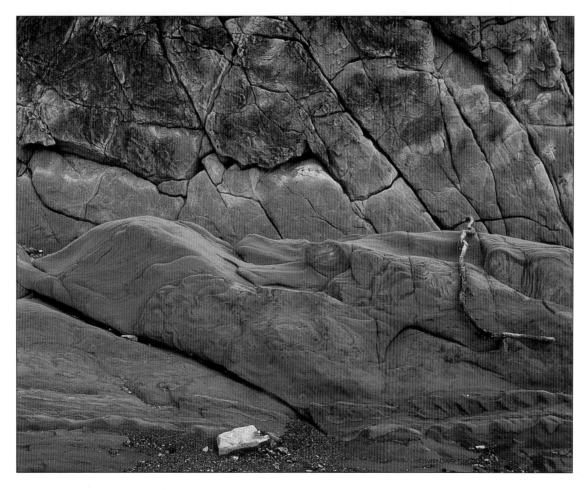

Water-molded sandstone

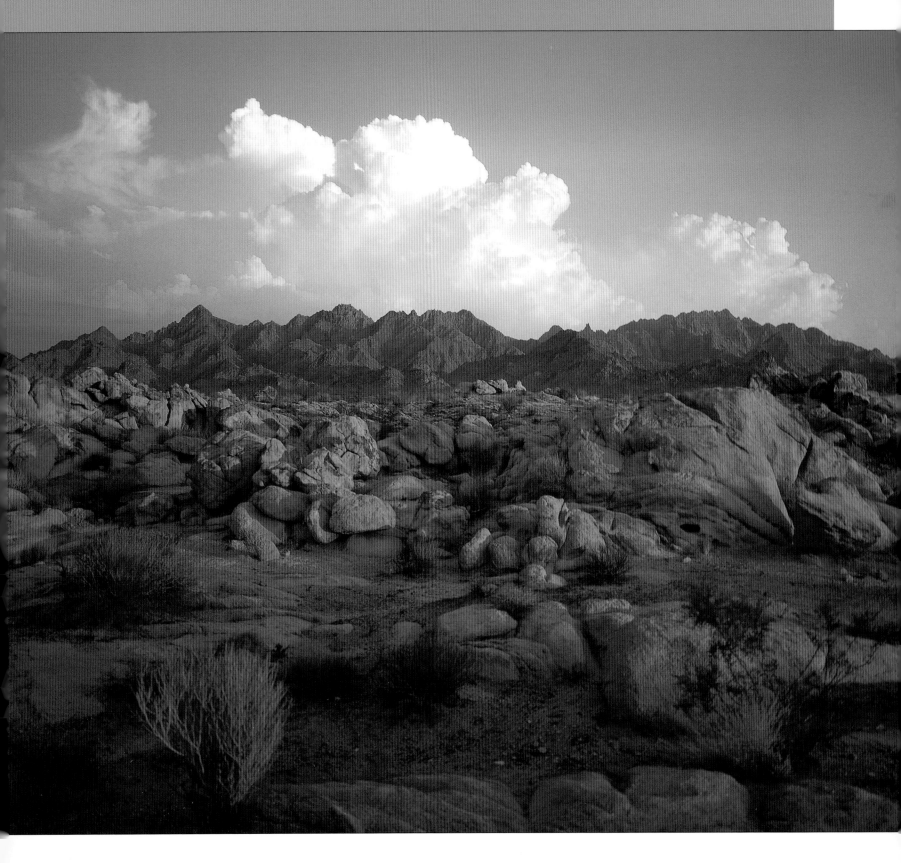

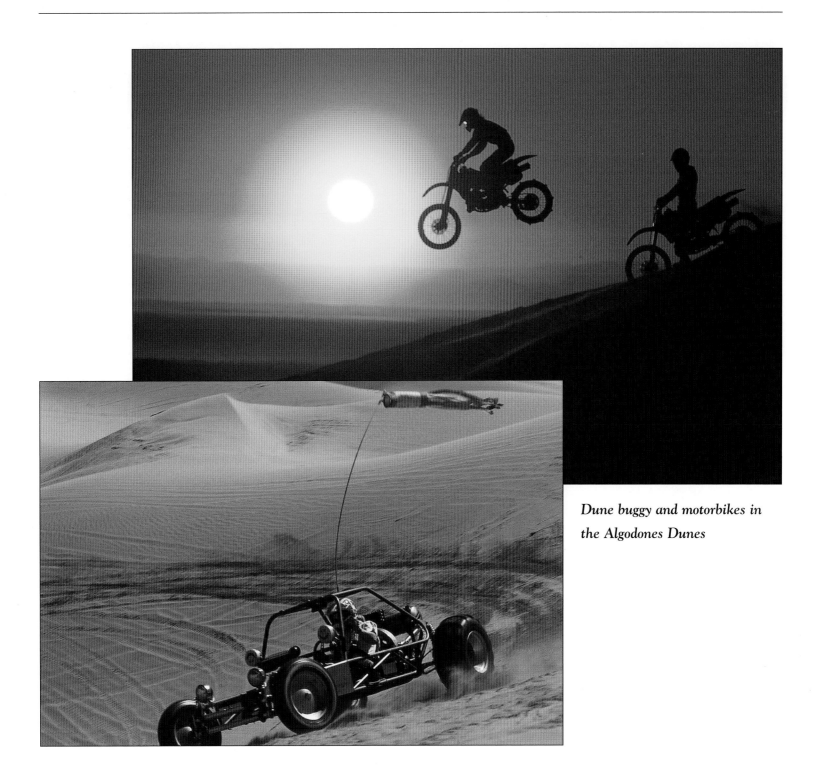

Dune buggy and motorbikes in the Algodones Dunes

Left: Sunset in the Coxcomb Mountains

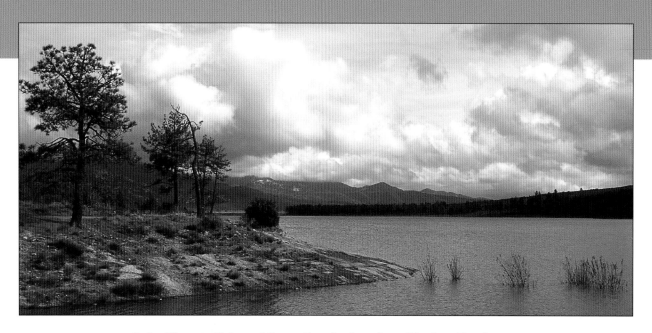

Lake Hemet; Below: Mount San Jacinto from Hurkey Creek area

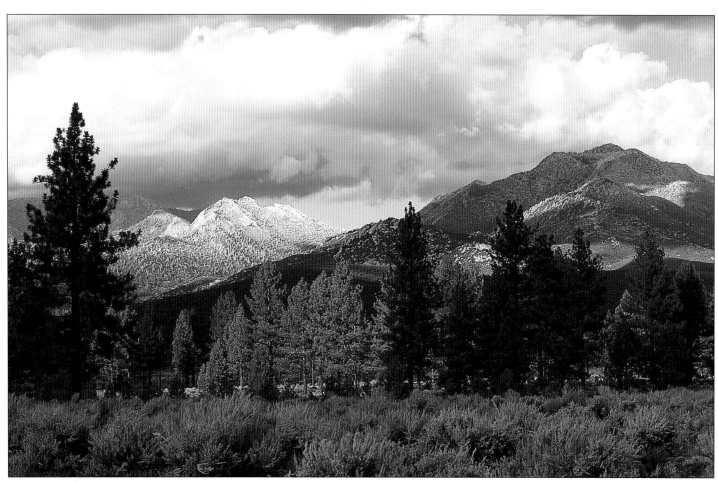

Lily Peak from Humber Park; Below: Lake Fulmore

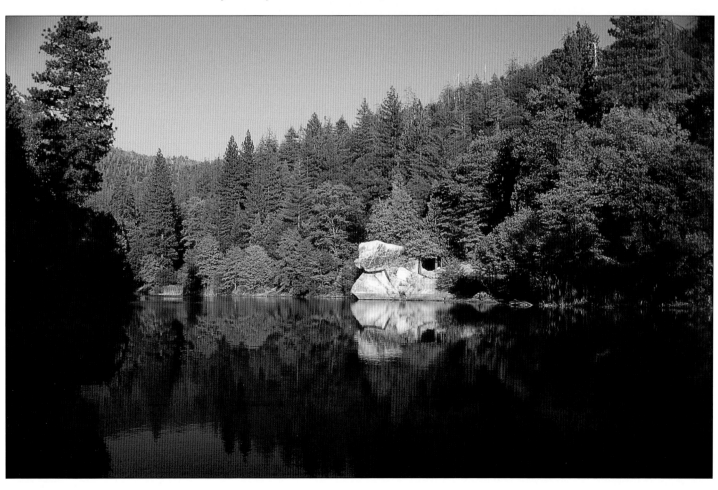

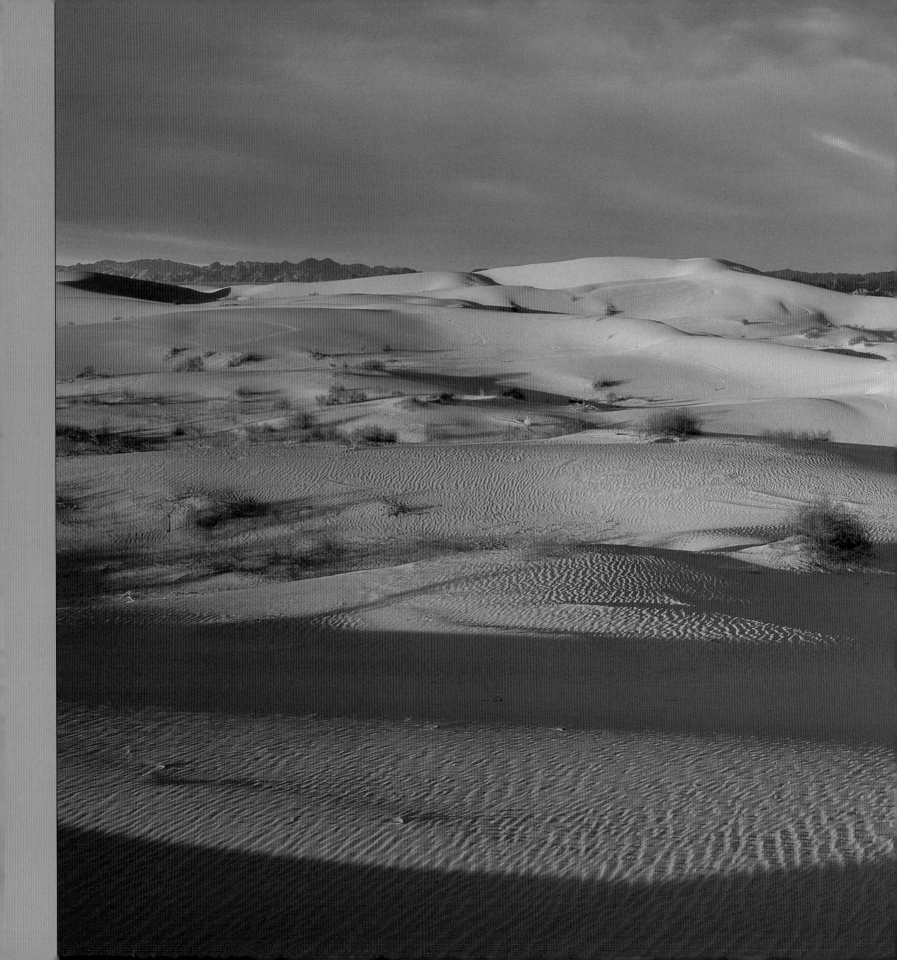

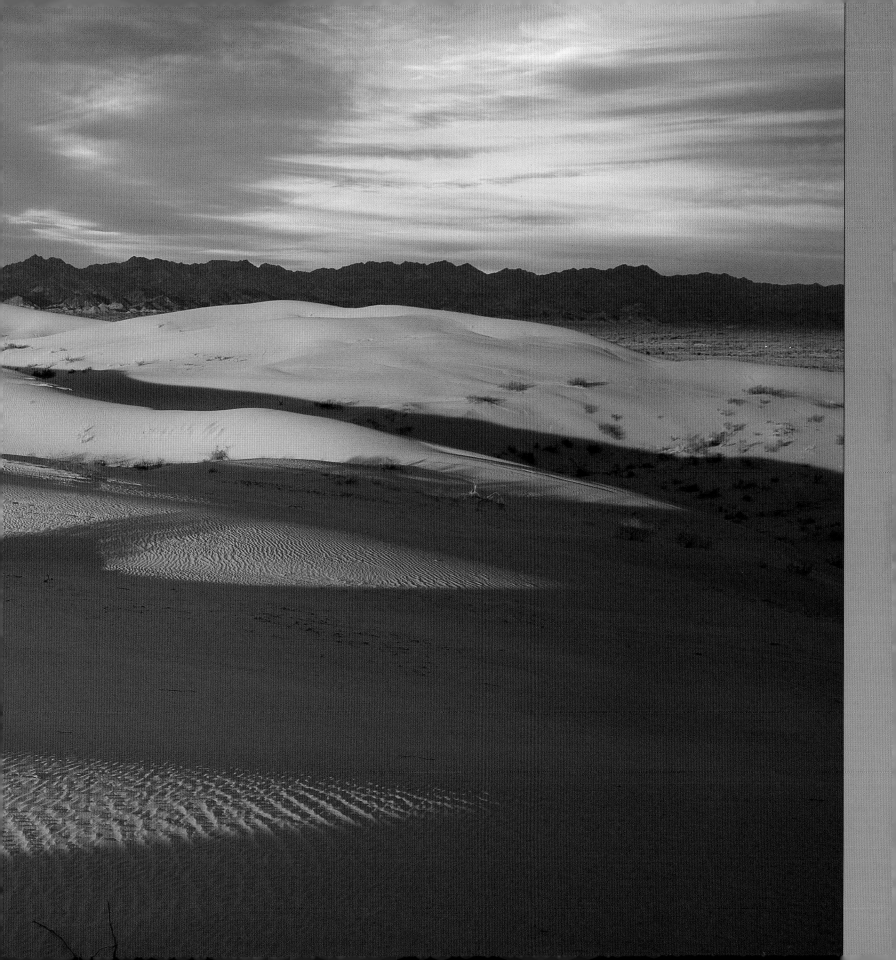

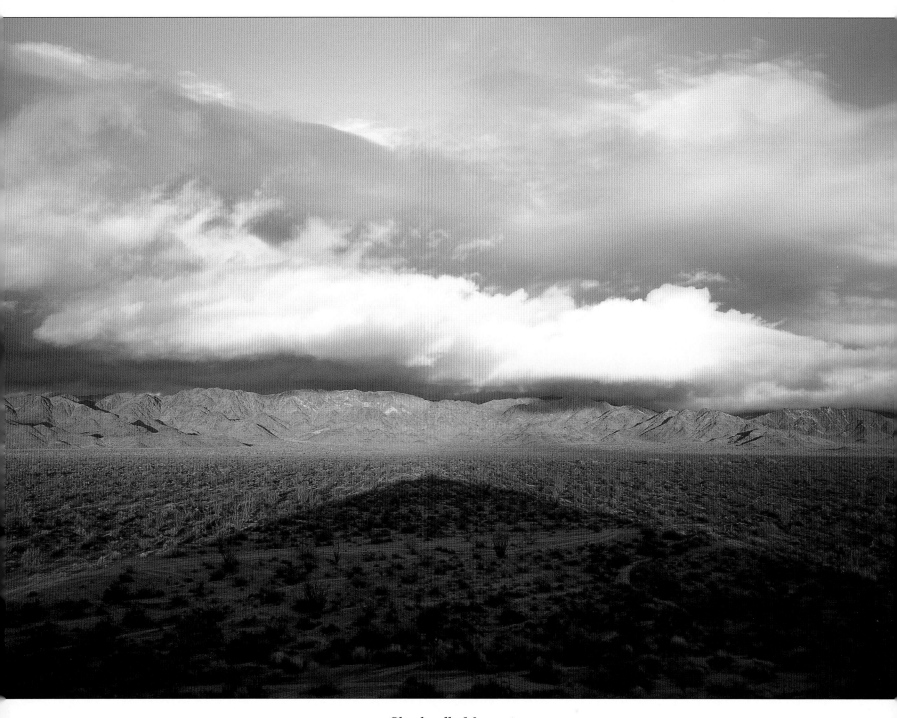

Chuckwalla Mountains
Preceding page: Algodones Dunes

Right: Concretions in a wash, Mecca Hills

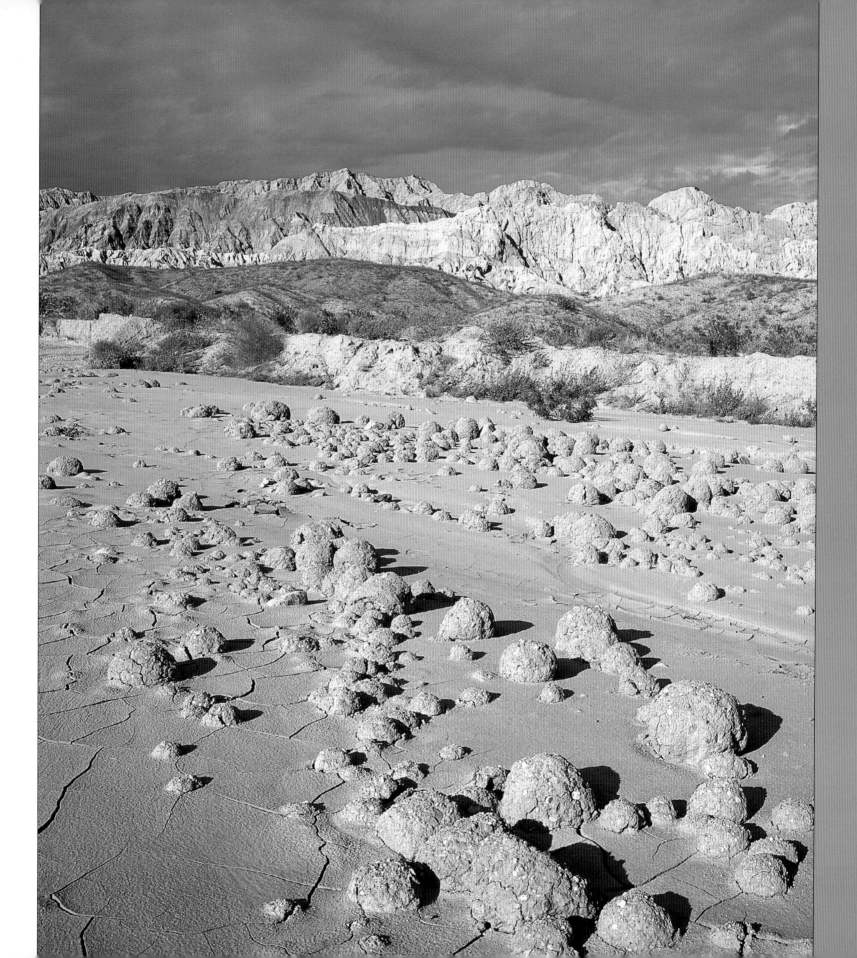

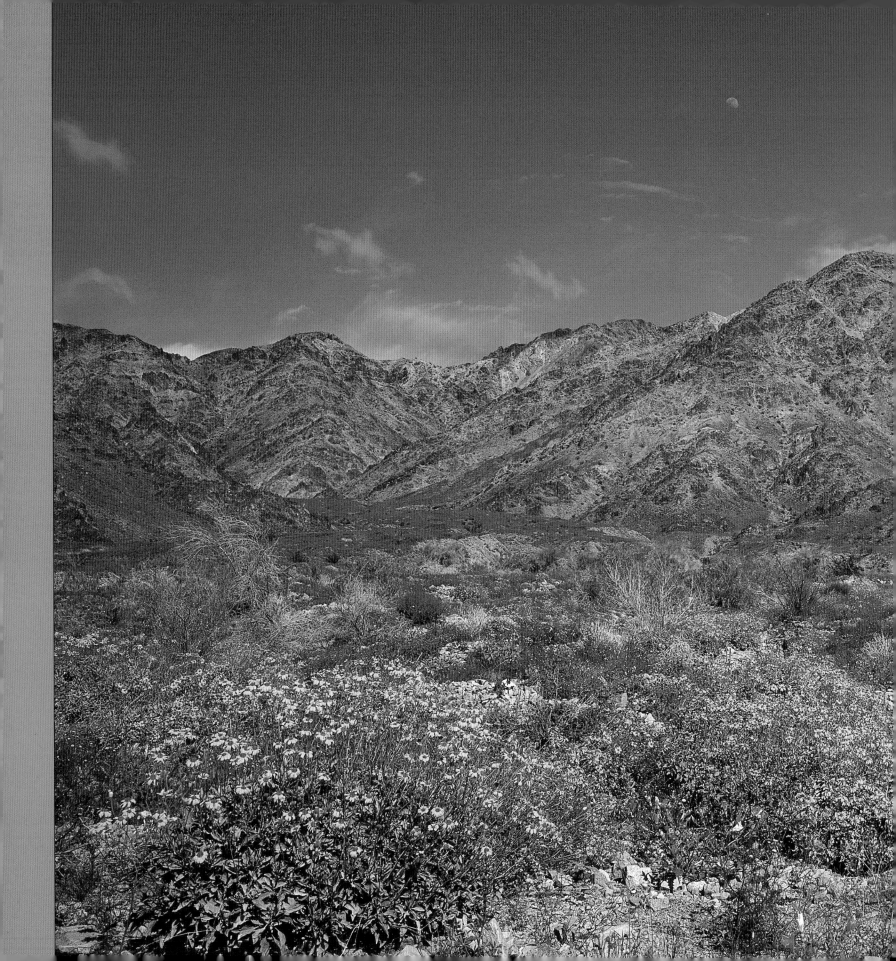

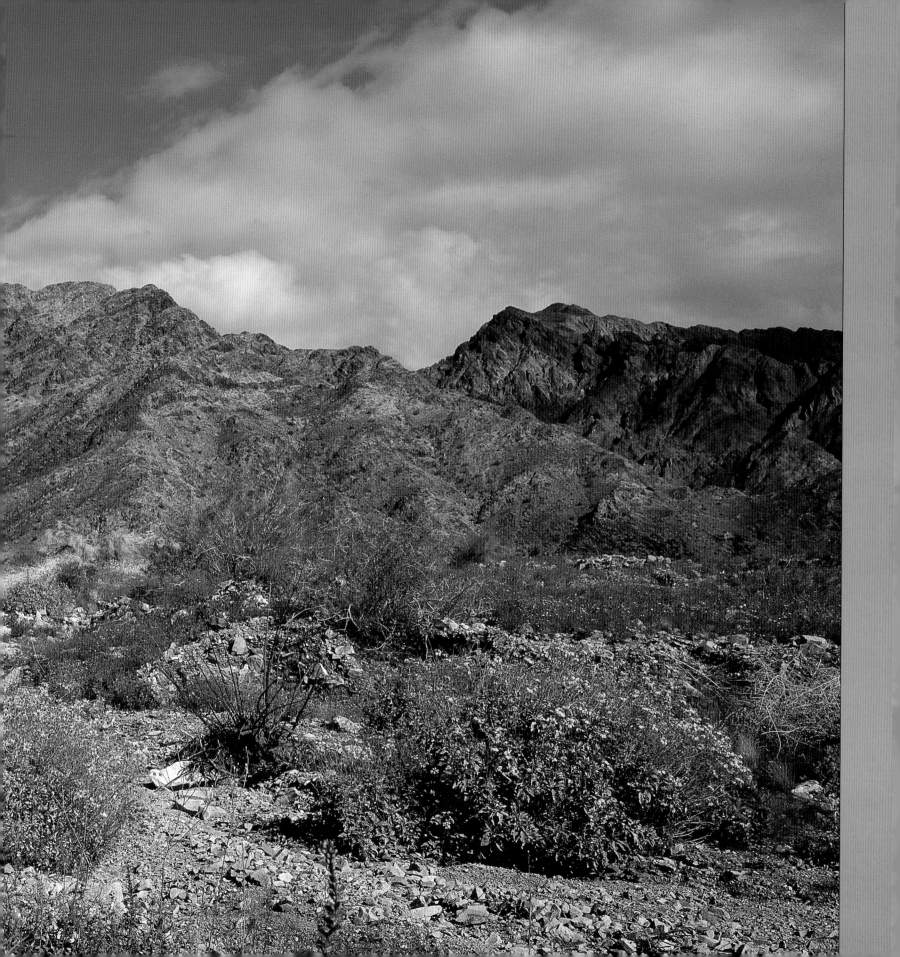

International Standard Book Numbers:
ISBN-10: 1-56579-552-0
ISBN-13: 978-1-56579-552-5

Editor: Eric Raetz
Designer: Angie Lee, Grindstone Graphics, Inc.
Production Manager: Craig Keyzer

Published by:
Westcliffe Publishers, Inc.
P.O. Box 1261
Englewood, CO 80150

Printed in China by: World Print, Ltd.

Library of Congress Cataloging-in-Publication Data:
Navez, Ren, 1953-
 Palm Springs : California's desert gem / by Ren Navez.
 p. cm.
 ISBN-13: 978-1-56579-552-5
 ISBN-10: 1-56579-552-0
 1. Nature photography--California--Palm Springs Region. 2. Deserts--California. 3. Palm Springs (Calif.)--Pictorial works. I. Title.
 TR721.N42 2005
 779' .36794--dc22
 2005024385

For more information about other fine books and calendars from Westcliffe Publishers, please contact your local bookstore, call us at 1-800-523-3692, or visit us on the Web at www.westcliffepublishers.com.

The author and publisher of this book have made every effort to ensure the accuracy and currency of its information. Nevertheless, books can require revisions. Please feel free to let us know if you find information in this book that needs to be updated, and we will be glad to correct it for the next printing. Your comments and suggestions are always welcome.

Preceding page: Chocolate Mountains